The FARMHOUSE

CLASSIC HOMESTEADS OF NORTH AMERICA

BY NANCY L. MOHR

COURAGE
BOOKS

AN IMPRINT OF RUNNING PRESS
PHILADELPHIA · LONDON

Printed in China

This book may not be reproduced in whole or in part, in any form or by any means, electronic or mechanical, including photocopying, recording, or by any information storage and retrieval system now known or hereafter invented, without written permission from the publisher.

9 8 7 6 5 4 3 2 1
Digit on the right indicates the number of this printing

Library of Congress Cataloging-in-Publication Number 2002100387

ISBN 0-7624-1388-3

Text © by Nancy L. Mohr

Cover design by Gwen Galeone
Interior design by Maria Taffera Lewis
Edited by Sally Clark-Sheola
Photo research by Susan Oyama
Typography: Meridien and Palatino

This book may be ordered by mail from the publisher.
But try your bookstore first!

Published by Courage Books, an imprint of
Running Press Book Publishers
125 South Twenty-second Street
Philadelphia, Pennsylvania 19103-4399

Visit us on the web!
www.runningpress.com

Front cover photograph:
Willa Cather House, Rockport, ME by © Brian Vanden Brink

Back cover photograph:
Hancock Shaker Village, Pittsfield, MA by © Paul Rocheleau

Contents

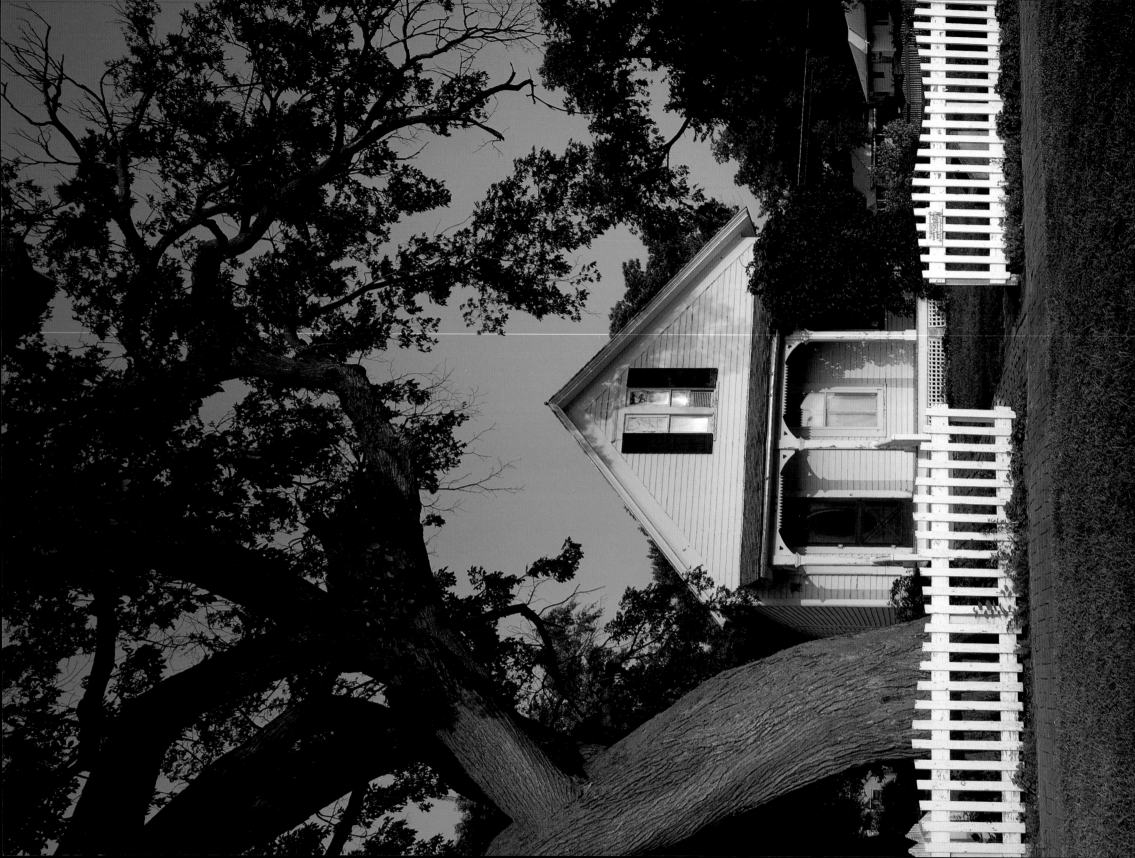

My Fascination with Farmhouses

WHEN DOES FASCINATION with old houses, and farmhouses in particular, settle in the mind and heart, capturing one forever? Hardly a conscious I-am-going-to-fall-in-love endeavor, it likely reflects a gentle gathering of stories that have slipped into corners of our minds. It is the product of enjoying and then sharing with our youngsters cherished, warm, wonderful tales of families brought together, kept together on the land. Reality also sets in with heart-rending tales of farmers uprooted by devastating droughts, floods and dust storms or simply overwhelmed by corporate agriculture.

Farmhouses perhaps seem more lived in than other houses, for their histories record tightly-knit cycles of work, love, respect and loyalty—values that are elusive and yet still appealing. These houses are comfortably worn at the edges, on the stair risers and hearthstones. Their imperfect glass windows ripple in the sunlight and floorboards creak. Rarely is a vertical or horizontal plane absolutely vertical or horizontal. For those who appreciate them, these well-used houses only get better with time.

Farmhouses hark back to an era that has all but disappeared. They speak of the courage of

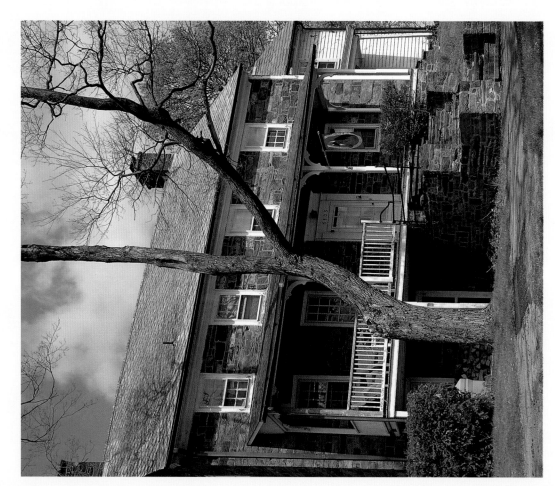

E VERY FARMHOUSE STORY has a beginning. For my husband and me, a pair of Connecticut Yankees, our first chapter began with a move to Maryland that led to a small farmhouse in the bucolic Greenspring Valley. The house was pure storybook heaven—white with green shutters, tall trees, a brook bordered by a

the early pioneers and settlers, whether in the rock-ribbed hills of New England, the fertile ground of the Middle Atlantic States, the hot, rural South with its plantations, the wide prairie, the Wild West or north into Canada. They embody stories to discover, embellish and pass on.

The farmer of today still lives a farmhouse life, whereas modern commuters and former city dwellers "borrow" farmhouses where they are available. The one sustains a physically and emotionally demanding lifestyle that confronts unpredictability. The other dreams of getting

away, leaving road rush and urgency behind. In between, it is possible to capture some of the best of both worlds.

Perhaps you yearn to explore or live in a farmhouse. Do you slowly cruise back roads looking for very old structures, crude or elegant? Is there already an architectural form that has become a favorite? Are you ready for surprises, just plain curious, open to learning about the genesis of a style or how it responded to the needs of the builder?

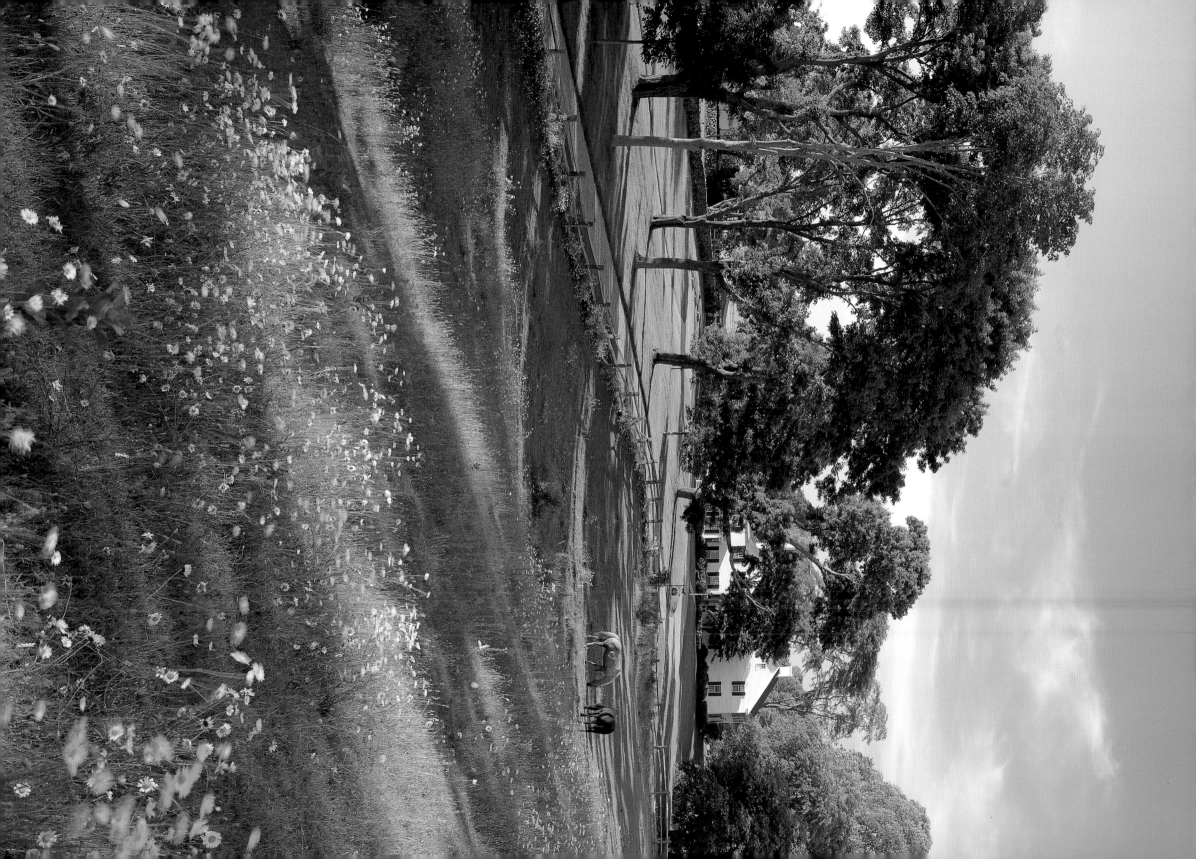

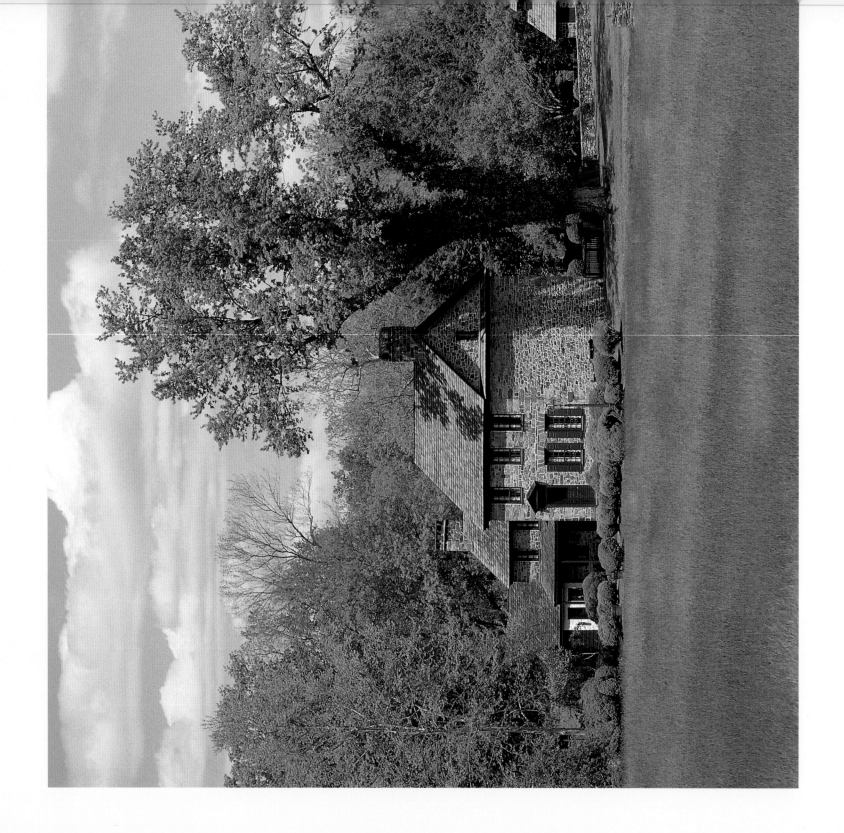

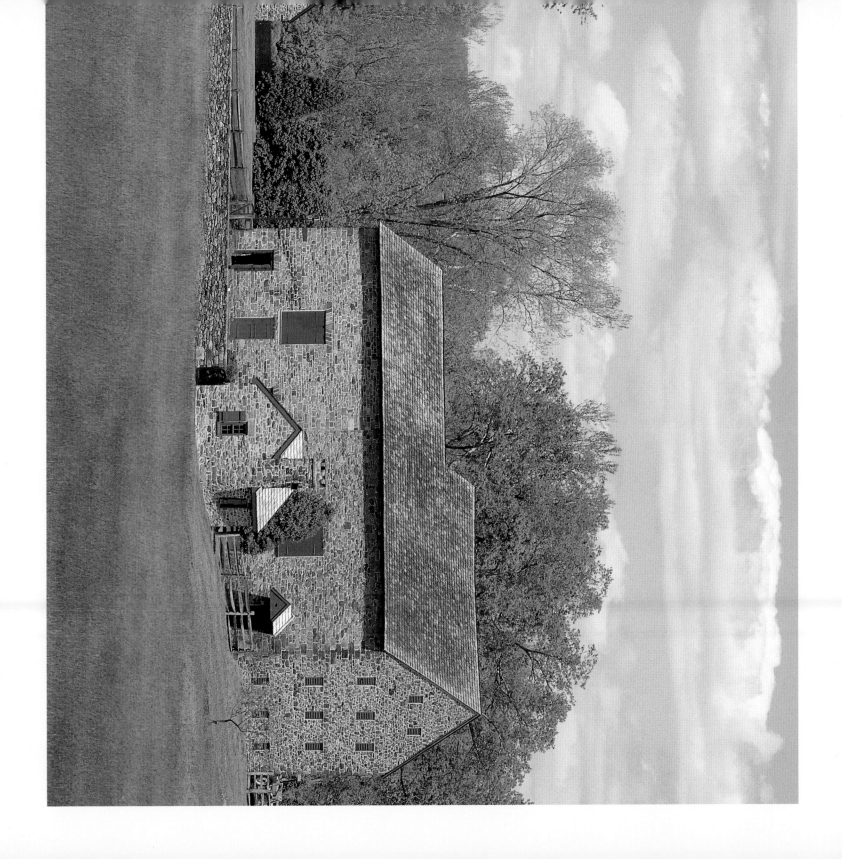

(**Above**) The Burgess-Lea House and Barn, Bucks County, Pennsylvania.

sunny meadow.

Once ensconced in the house, my days were filled with making curtains, digging a first vegetable patch, discovering old-fashioned double daffodils and wildflowers in the weedy gardens, harvesting watercress fresh and crisp in the dribbly brook by the barn. We had been country-bitten for life.

The days and weeks of six years there are registered deep in our hearts—good things, others iffy, such as absences of electricity and light bulbs that exploded in storms. The little farm-

house shrank with the addition of children. But when summer came, we'd revel in this lovely place and forget we no longer fit.

One fall, another job change took us to Philadelphia. Serendipity led this time to a 1703 farmhouse with six fireplaces—each one with a mantel that reflected a different cultural or period influence, beamed ceilings, a summer kitchen-den, surrounded by 200 acres of farmland with a Toonerville-trolley kind of train station a half mile down the road. The windowsills were so low that a two-year old could rise on his

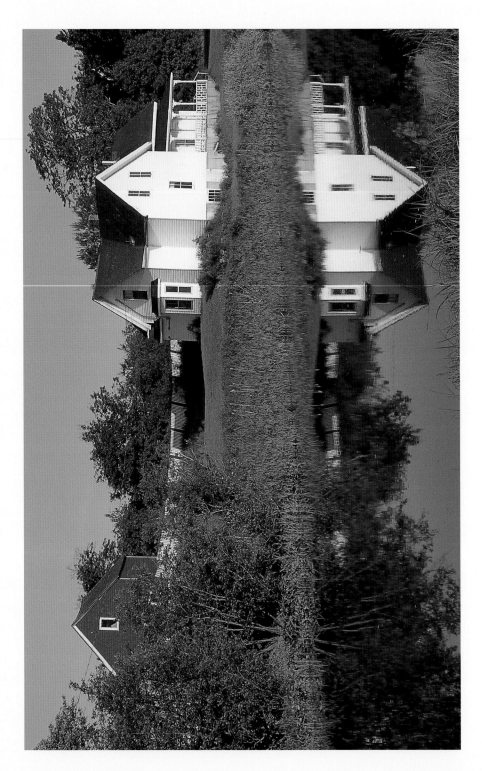

(Bottom) This Wheatley River home, in Prince Edward Island, Canada, was built in the later 1800s.

The windowsills were so low
that a two-year old could rise on his tiptoes and exclaim,
"Mom, it's a moo-cow house!"

tiptoes and exclaim, "Mom, it's a moo-cow house!" Sure enough, part of the package was the forty or fifty Hereford and Black Angus cattle—up close and personal.

1703—it was hard to imagine that many years. The house was typically Pennsylvanian in its one-room-wide construction, beginning on a gentle hillside and walking up and down as additions were built. The front door opened into a large square room with a huge walk-in fireplace. Down several steps opposite the door, the summer kitchen was built around the well—a fifty-foot dug well in the middle of a stone floor with a heavy cover that took two strong adults to lift. The back or south wall was stone and brick, with a fireplace and bake oven that drew like a charm. Deep floor to ceiling bookshelves probably evolved from a small loft. There were two Dutch doors, whose top halves could be opened for ventilation—with glass obviously added at a later date.

Back in the main—now dining—room, a turn uphill (one step higher) led to the living room which was once two rooms, with different styles of corner fireplaces in opposing corners (the fireplace location revealing Swedish influence). One fireplace had a rather formal surround mantel, the other a broad, tapered shelf wide enough for candles.

The stone sections imparted solidity and provided some natural insulation. The windows, set in thick stone walls, were deep silled. The corners were rounded and the windows sashless, six over twelve panes. The floorboards in the dining room spanned at least a foot, eighteen inches in places. The hearth was a heavy single slab some ten feet in length.

Several steps downhill led to the frame section, estimated to be late 1800s. Alas, a cold wind from the northwest did its chilly work on cloudy days. In contrast, a sunny morning filled the room with warmth and a beautiful view over the little

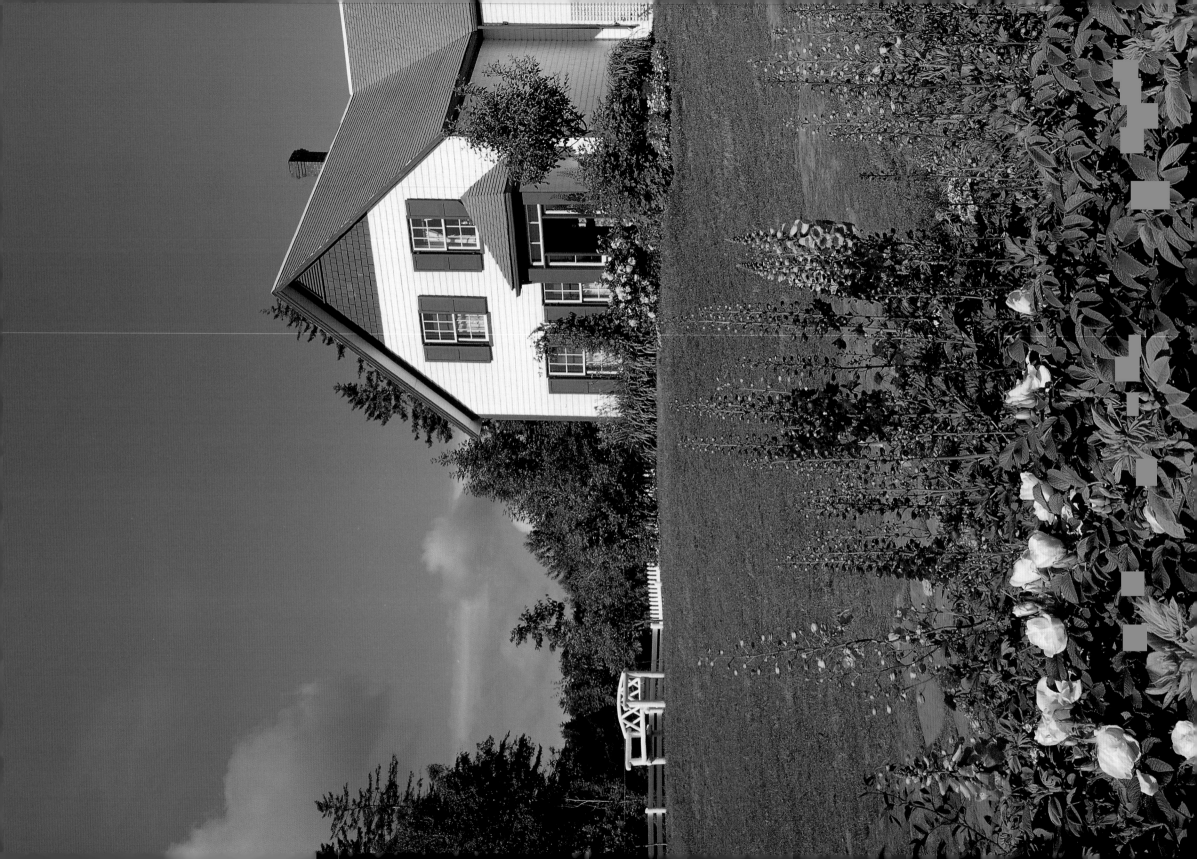

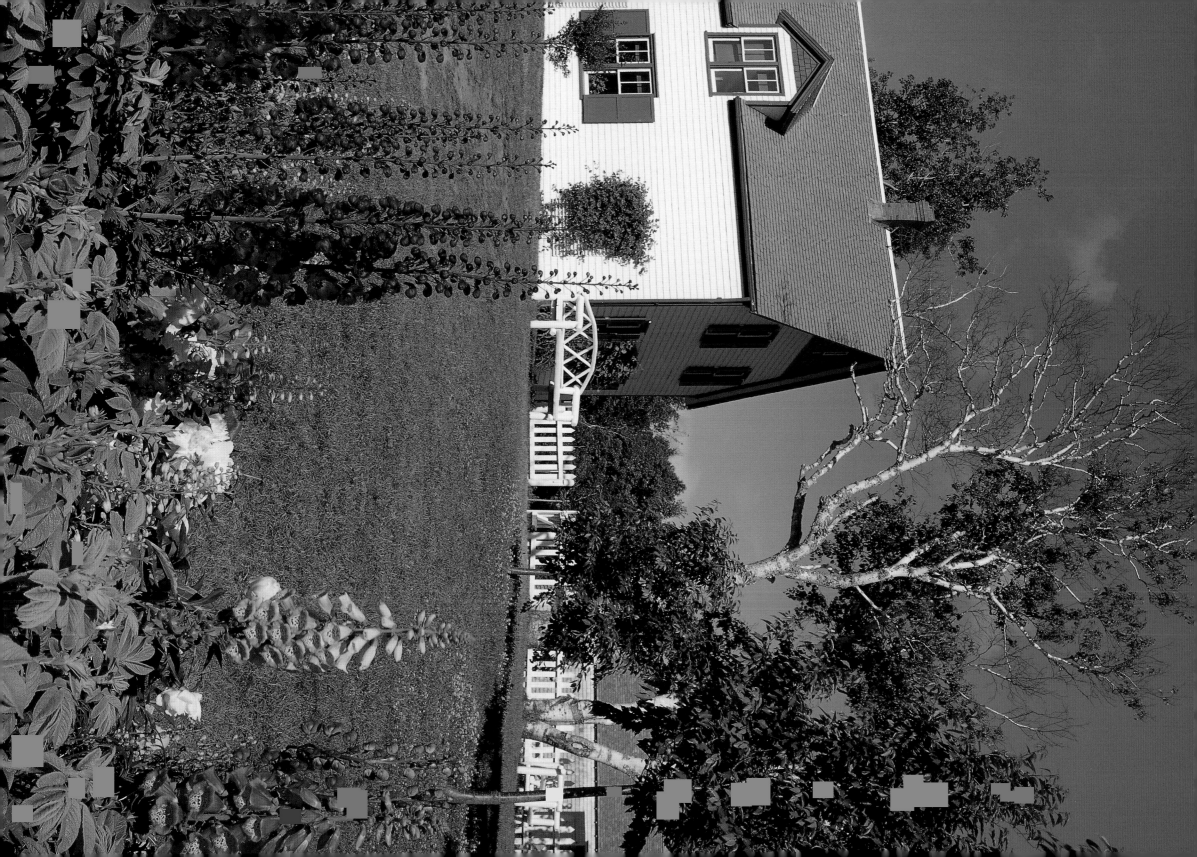

(Overleaf) Green Gables House, Prince Edward Island. This achieved world-wide fame as the inspiration for the setting in Lucy Maud Montgomery's classic tale of fiction, *Anne of Green Gables*.

(Top) This house by a stream is in Green Spring Valley, Baltimore County, Maryland.

(Right) This farmhouse interior is part of a farmhouse in Hancock Shaker Village in western Massachusetts.

stream valley. Lilac trees and a gigantic willow outside the summer kitchen testified to what lay ahead in spring. Just to the east, a small red barn with white scalloped trim begged for ponies and horses, a few chickens—and exploration.

UPSTAIRS, at the end of a winding stair-case, is a large bedroom with windows on three sides. (Just looking at it made it clear it would need a plentiful supply of quilts.) Off the second floor landing, a large bathroom filled a small connecting room. Travel from one end of the second floor to the other required passage

through the bathroom—fairly typical in modernized old houses. Another bedroom on the same level included a pretty, nonfunctional fireplace, and a chair rail with faded flowery wall-paper above. The random width flooring on which nothing remained level was crafted of the most beauti-ful shade of green poplar—truly special.

Up one more landing was a master bedroom that must have seen its share of babies delivered. Breathtaking views complemented the low beamed ceiling and simple corner fireplace.

The careful restoration of this house that breathed antiquity made it feel like home immediately. We had lucked upon a house with all the charm and none of the agony of restoration. We could concentrate on living, gardening, chasing moocows out of the yard, and trying for a real vegetable garden. We were learning to be better country people—and loving the fact that the

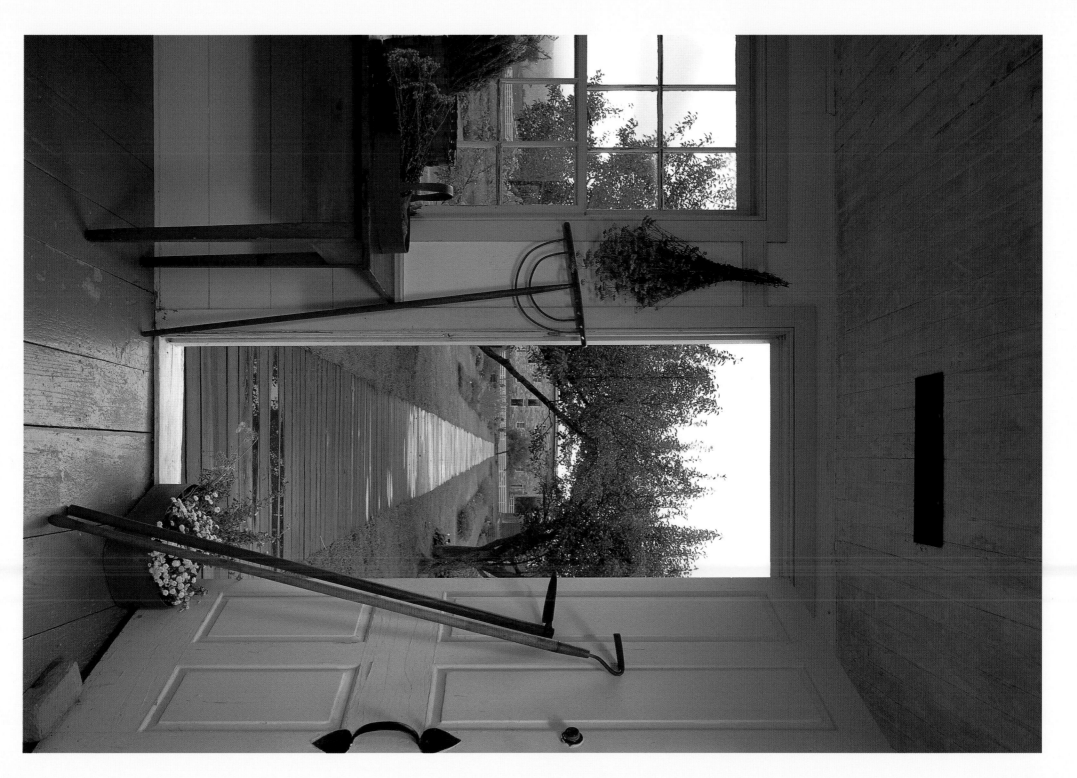

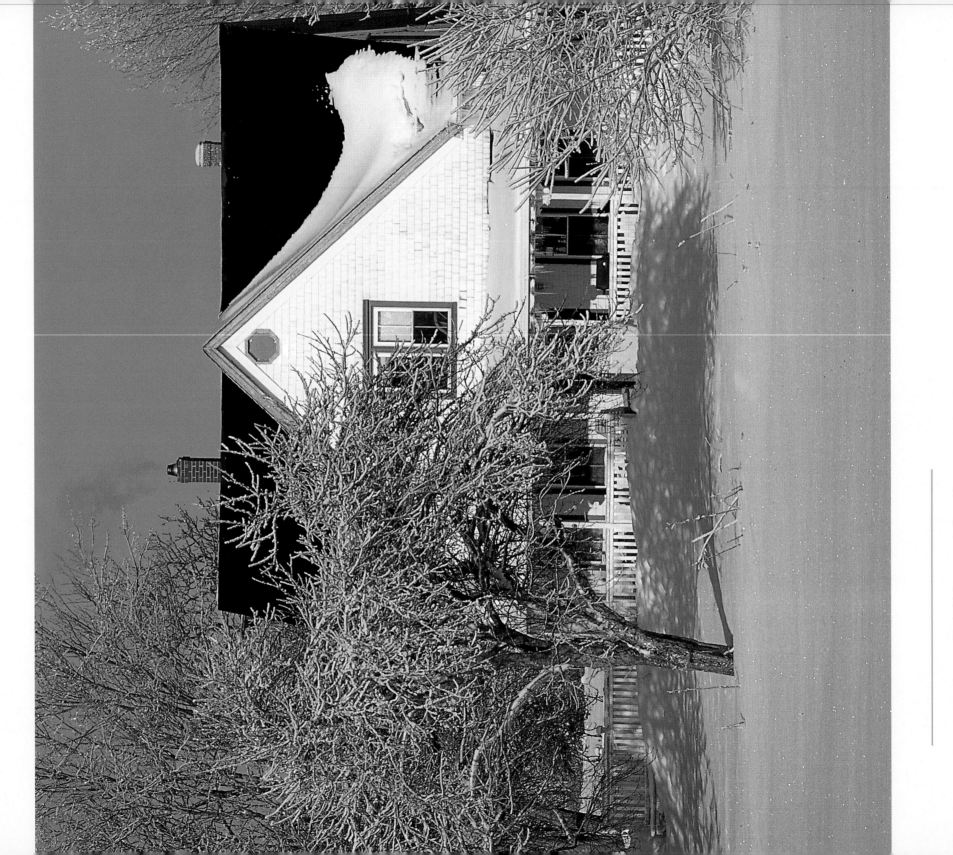

(Top) This house was built—without a blueprint—by John MacNevin around 1875 in St. Catherine's, Prince Edward Island, Canada.

train station was an easy walk in all but the worst weather. The catalyst to move on came when the owners decided to grow houses rather than cows and hay.

Now confirmed country farmhouse dwellers, we were suddenly searching in earnest. It was time to buy, to put roots down. We talked to agents, knocked on doors. We lost ourselves on back country roads. We became very discouraged.

One very cold wintry day, there was a house to look at. It didn't sound promising. Half a mile from a new, partially constructed bypass, it was a small farm (twenty-five acres) carved from a larger property that would eventually be sold for a golf course.

The house was large, with half a dozen intriguing-looking outbuildings. When the farmer's widow opened the door, the front hall seemed warm enough to leave coats on a chair. Bad move. A curtain suspended halfway up the front stairs hinted at what was very quickly felt:

> The house had no central heating, no insulation, antiquated plumbing. Yet only a week later we were dickering on price.

the absence of central heating. The living room had no fireplace, just a mantel where a Franklin stove once stood. A short hall led to a darkish kitchen and a door to narrow winding stairs.

Beyond that a wood/coal stove crackled away in the adjacent summer kitchen.

French doors led into the dining room (a late addition) with a sunny bay window, wonderful deep windows and vestiges of another Swedish-style corner fireplace. Along the way, this farm had also been prosperous enough to pick up modern "improvements." Aluminum siding covered the entire house, hiding the thick stone walls of the dining room wing (early 1800s) and the German siding of a Victorian addition. A small front porch dated from the Victorian era.

The upstairs featured four bedrooms and an extra room, plus an attic. The house had no central heating, no insulation, antiquated plumbing. Yet only a week later we were dickering on price. So much to do, new heating, new

wiring and a host of surprises. Six weeks later, we signed an agreement that brought the land down to 16 acres but met most of our other requirements.

From the kitchen window the view was a southeastern Pennsylvania version of undisturbed plains. Our kids (now five in number) thought they had landed in nirvana: there was a stream to play in, a huge barn for hide and seek, a carriage house, a low building destined for a rainy day playhouse large enough for riding tricycles. We were dirty, tired and happy every day, and much happier when the well came in at seventy-five feet and forty-five gallons a minute. Thank goodness the weather was warm, so baths in a chilly room weren't bad at all.

Little by little, the house shaped itself to the family's needs. Down came the plaster in the dining room ceiling to reveal quite nice beams. The number of animals and fowl increased: horses and ponies, a Sicilian donkey, chickens, a Wilma-ish pig, ducks, geese. The best swing tree rounded out all the experiences that a large family learning country life could possibly have. A flooded cellar drowned the brand new furnace that miraculously turned on again, blizzards

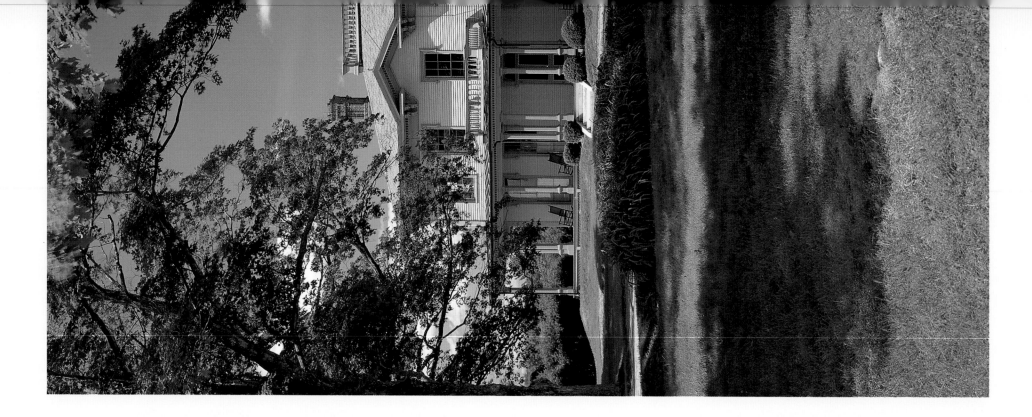

(Above) A front view of the Washburn family mansion, Norlands, in Livermore, Maine.

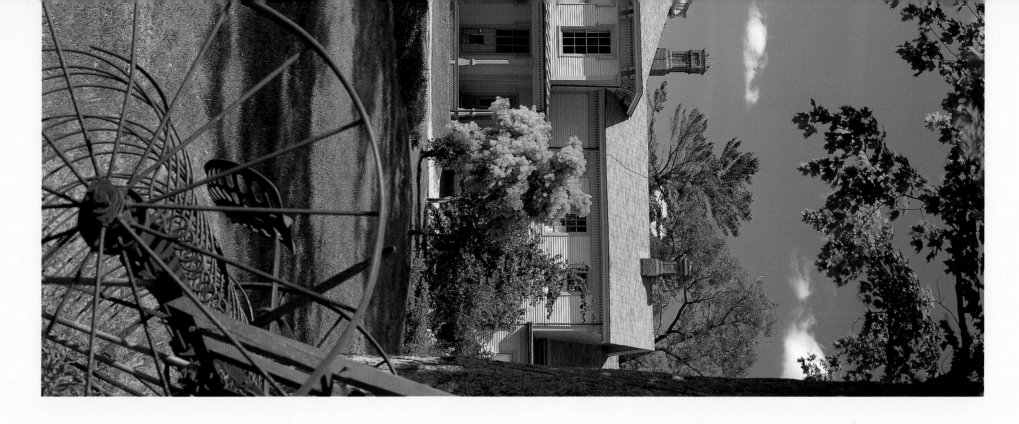

O<small>UR ORIGINAL IDYLLIC THOUGHT</small> was that moving here would lead to our dream place. And, ultimately we found land overlooking a magical valley seen and then lost on one of the early wandering forays. The next step was designing and building a new-old house.

Anyone who contemplates creating their farmhouse anew from old materials must recognize up front that they have chosen the most expensive option. Only my husband's inspiration to "take the biggest barn along" made the house possible. Suffice it to say that the combination of Amish carpenters dismantling the 1867 barn, then helping to put much of it back together, a crew of Italian masons, a lot of imagination and hard work resulted in a very comfortable, livable farmhouse. The once-small children and now their children consider it the best chapter of the family history.

And all because someone introduced us to the warmth and appeal of farmhouses.

buried the farm for days at a time, and the watch-geese chased a friend to the top of his car. You don't do this in the metropolitan suburbs. We loved it.

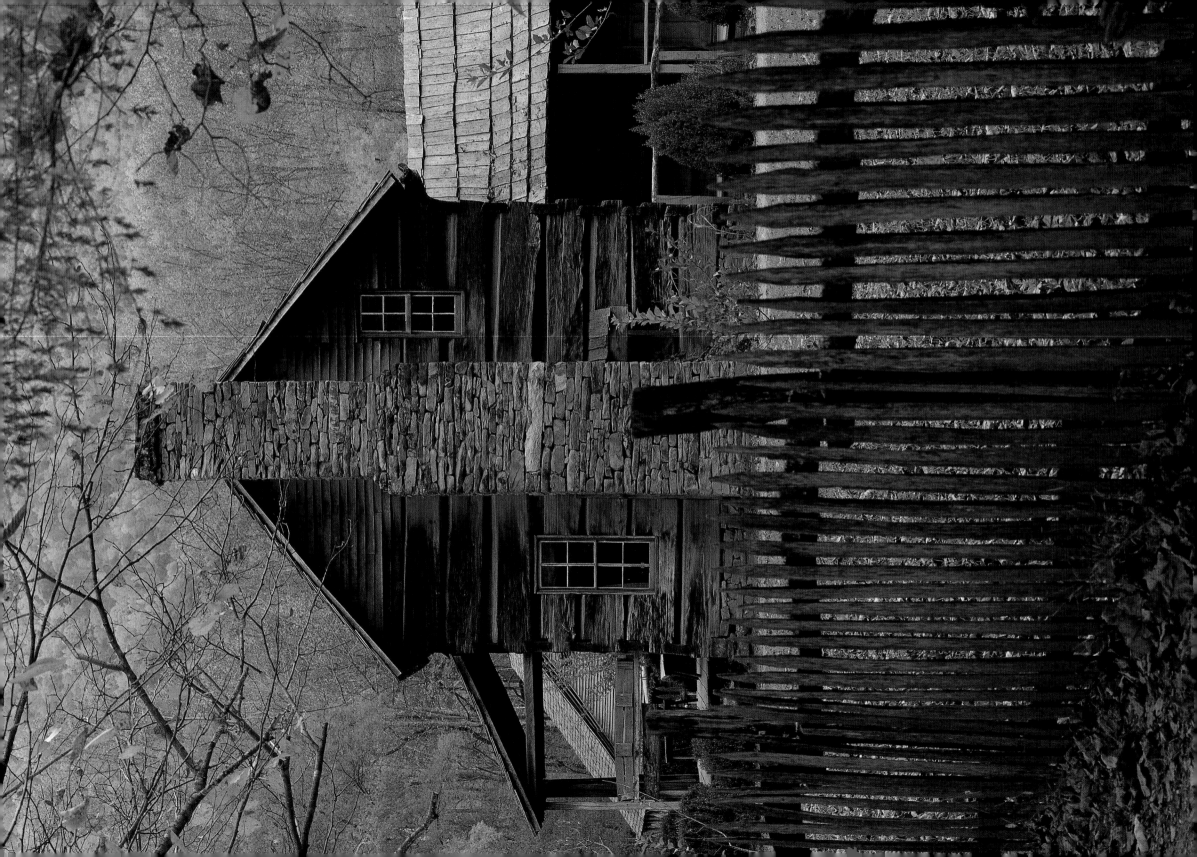

Early Farmhouses

T HE FIRST FARMHOUSES, built by hand, were quite crude. Shelter for work and dairy animals held the higher priority. The beginnings were simple—log cabins with heavy stone foundations, the products of clearing stones and trees from the land to plant crops.

Many of the hardy settlers arriving in North America to establish a new life in a strange world were not experienced farmers. They learned on the job, faced with the necessity of growing crops and hunting game if they were to survive.

Inventories of the tools shipped along with the Massachusetts settlers, compared to those of the early Virginia colonists, offer clues to the success and failures of each group. The New England-bound ships included plows and other agricultural tools, while the ill-fated Jamestown, Virginia, colony brought virtually nothing that would help put food on the table, resulting in a disastrous early history of starvation and failure.

Log houses were far more numerous than any other type of farmhouse in the first half of the eighteenth century. However, once the elements for survival were place, New England families joined forces to build one another's

A SINGLE SMALL FRAME HOUSE with a center chimney might have as its next addition a separate kitchen or a story-and-a-half Cape Cod with dormers providing extra space under the eaves. The saltbox design with a short front roof over two stories and a longer, sloping back roof that covered a shed, became a uniquely New England symbol. Windows and doors tended to be small, not only because glass was expensive but also to conserve heat and keep out intruders. The clapboard siding was usually horizontal to repel wind, rain and snow, while in other regions it was vertical.

The styles in the Northeastern states were simple and adapted well to families' needs. Farmhouses were shaped by the lives of their houses mostly of frame—a clapboard exterior with plaster inner walls, the basic structure good solid mortise and tenon. Families bartered labor for flour, meat and vegetables. The New England climate demanded south-facing buildings whenever possible and improved techniques to stay warm (a variable word in those days). Settlers lined the inside walls with planking and, if practical, nailed lathing over the planks and applied plaster as a final coat.

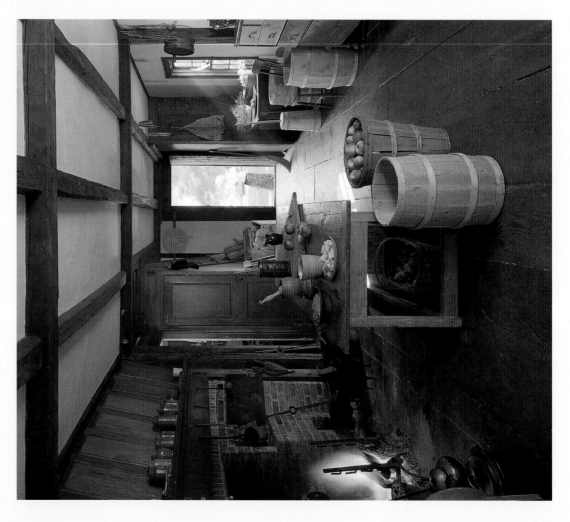

(Bottom left) The interior and hearth of Jefferds' Tavern, built as a farmhouse in 1754 in Wells, Maine. In 1939, the tavern was disassembled and moved to the Old York Historical Society in York, Maine.

(Right) This salt box house, originally built in New Hampshire in the 1700s, was moved to Standish, Maine.

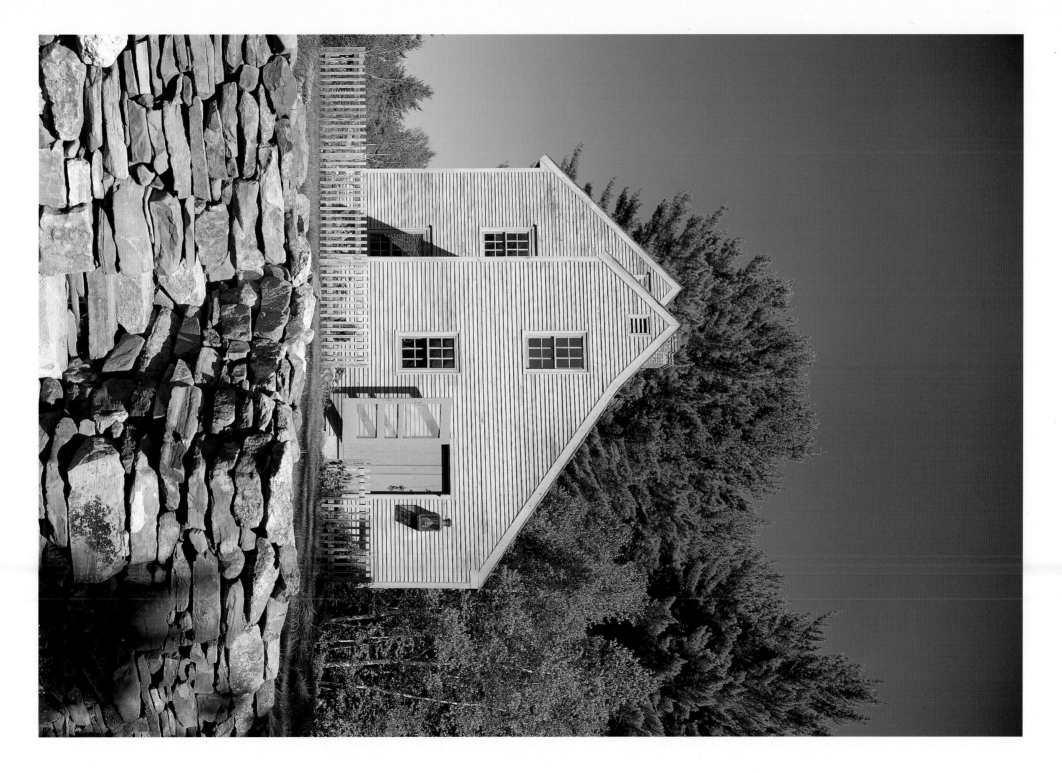

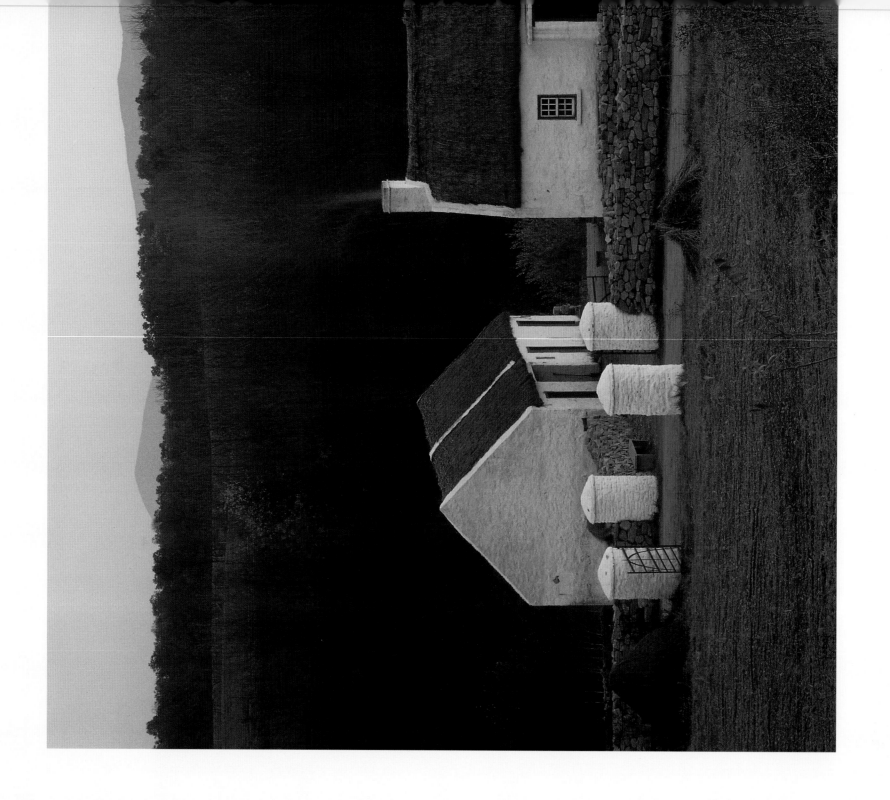

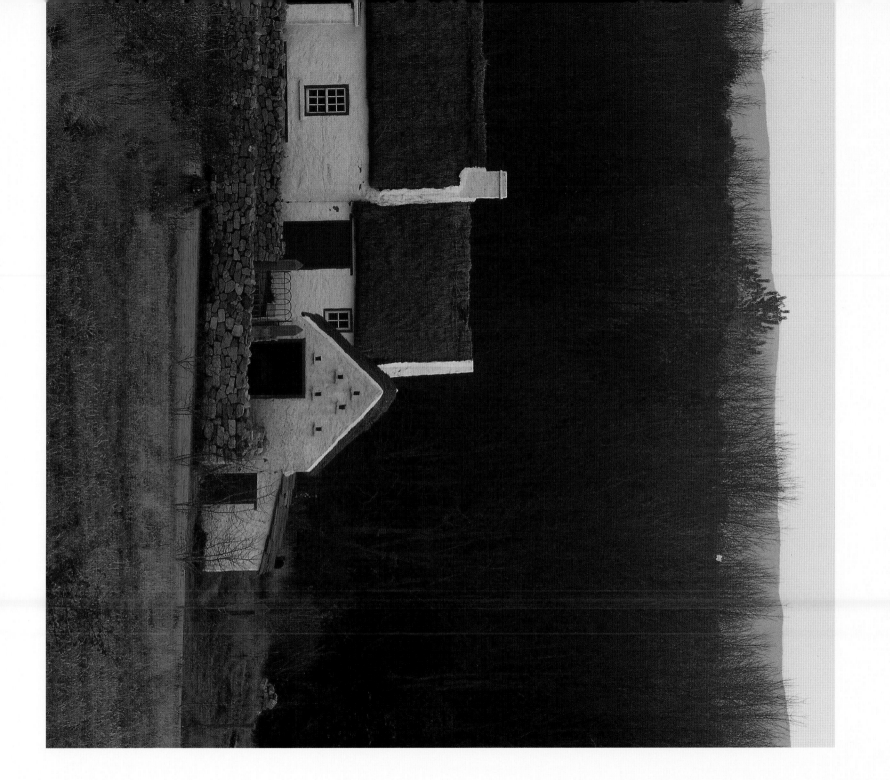

(**Above**) This Scotch-Irish Farm is part of the Museum of American Frontier Culture, Staunton, Virginia. It is typical of the solid tenant farms left behind by entire Ulster families from 1710-1830.

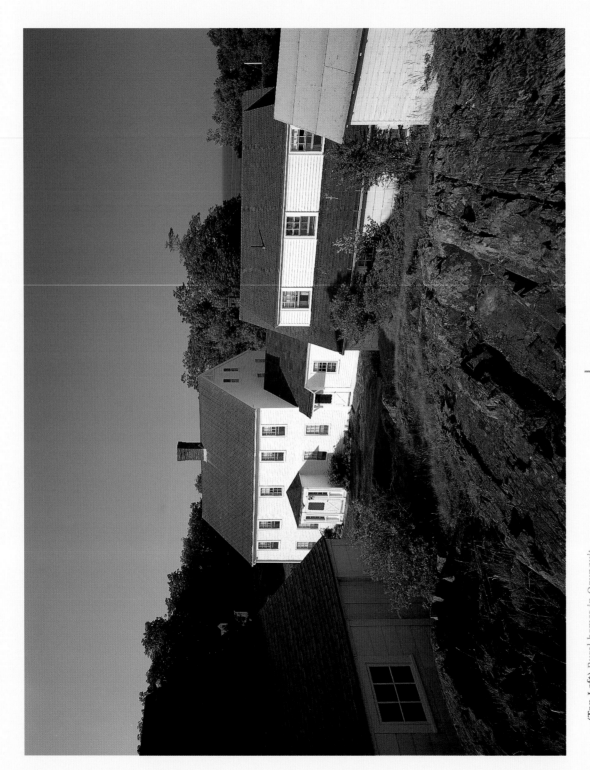

(**Top Left**) Rural homes in Ogunquit, Maine, an artist's haven whose beaches have attracted visitors from all over the world.

owners. A house is a structure, but the personality it develops makes it a home. There is a great appeal to the New England farmhouse, which gathered large and small additions, stringing out along the road or in a T-shape per-

pendicular to the road, but always ending with a large barn. Each addition had a purpose—the family gathering around the fire, a separate kitchen that considered safety, a workshop sheltered from the elements (if still not warm in the winter), maybe chickens and ducks in the next "box" and the big barn for cows, hay and grain. These farmers didn't worry about getting lost in

the blizzard as they tended to chores; everything was under roof.

Over more than 200 years, this basic design has endured well and gained in value. The transition from active farmhouse to village or town residence has been undramatic since the houses were typically built close to the road for access during the heavy winters.

Moving toward the Middle Atlantic area and its rich farmlands, imported design ideas mixed with practical responses to the physical realities. The Hudson River Valley attracted independent, hardworking farmers, many of them Dutch, who saw a ready market in Manhattan for their produce. When most people think of the Dutch, they envision the Hudson River area and the folklore of the Catskills. However, the Dutch settled over nearly 35,000 square miles running from Albany east to Hartford, Connecticut, and south as far as Delaware and Pennsylvania.

Cities began as villages and towns near good water and rich soils. The need for subsistence suggested the location. Sketches and paintings of New York City in the early and mid-1800s depict a central core with wooden sidewalks. As money flowed in to create a mercantile and financial center, businessmen built large houses along major thoroughfares like Fifth Avenue. Yet not too many blocks north, the city houses thinned out to make room for highly productive farms that supplied the city with milk, fresh produce, as well as hay for city horses.

New York State also had its own version of the below-ground cellar house, which was not just the province of sod houses on the prairies. A six or seven foot cellar would be floored with planks, the walls covered with slabs of bark and a roof of planks covered with bark and sod—with most likely a smoke hole in the ceiling.

A SINGLE-ROOM HOUSE of logs or board often followed the cellar hole, still with the primitive smoke hole and eventually a wooden chimney. More permanent dwellings tended to be stone or brick, often with sharply pitched roofs to gain extra living space. The idea of connecting the barn to the house never gained much popularity in this region. There was plenty of wood for construction, and although stone was more difficult to work with, it lasted longer. A major contribution of the settlers from the Netherlands was the Dutch door, a

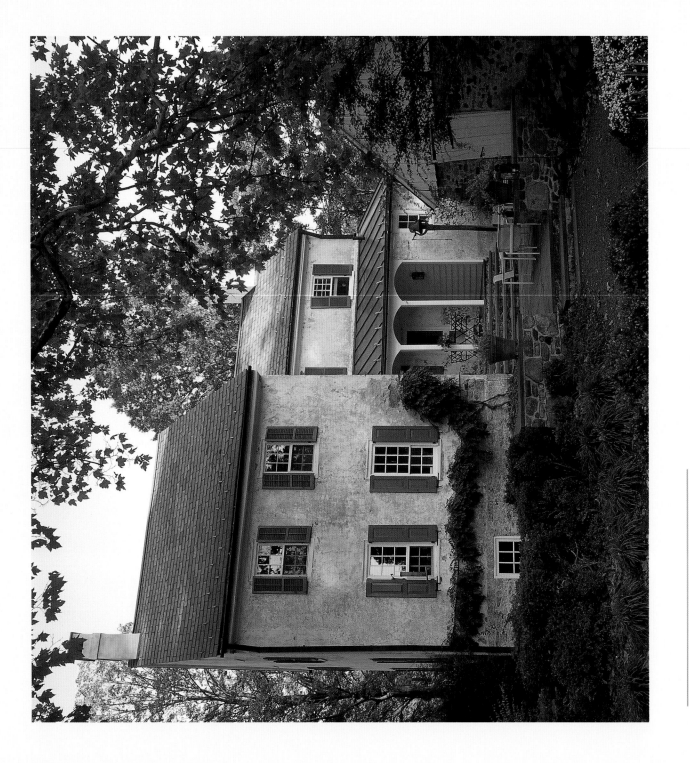

(Above) This charming two-story home was built around 1812 in Bucks County, Pennsylvania.

(Right) A close-up of the Burgess-Lea House, Bucks County, Pennsylvania.

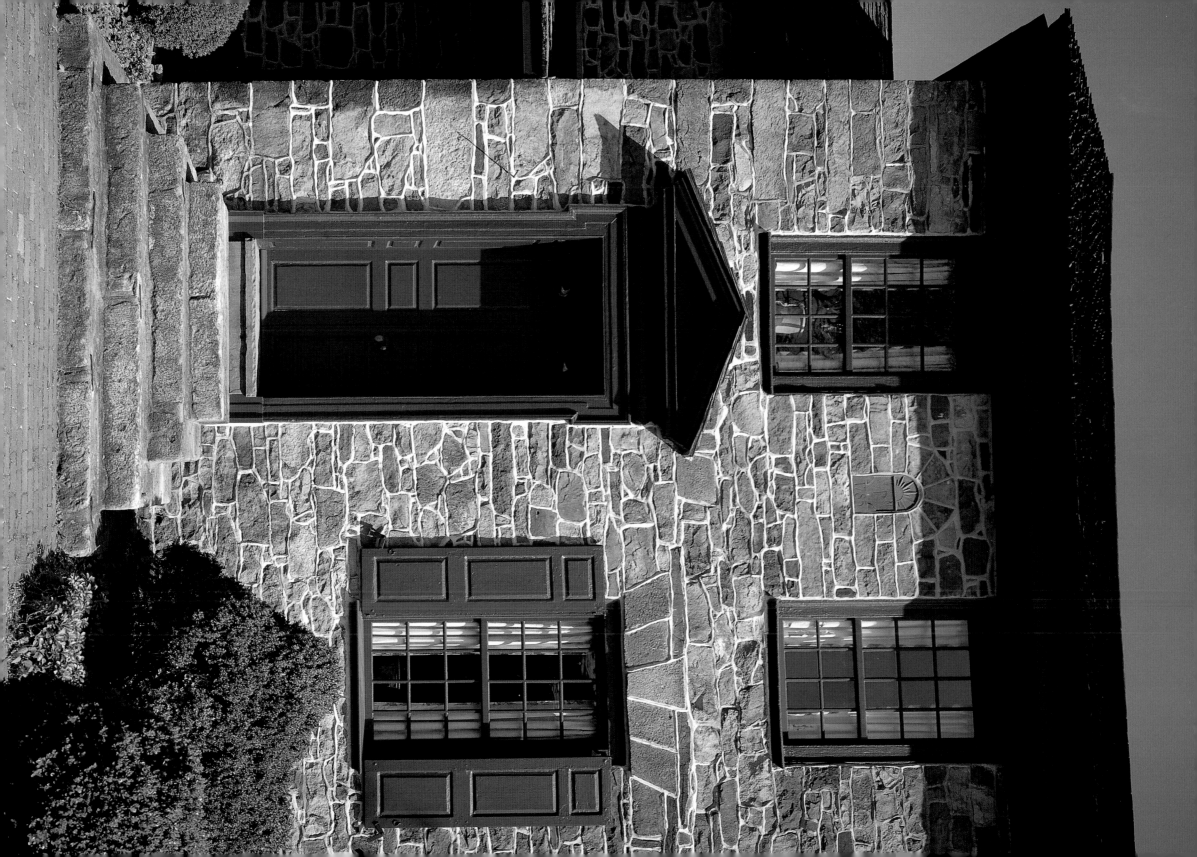

two-piece affair that allowed the upper half to open independently. These popular doors can be found all over the country in houses and barns, old and new.

In Pennsylvania, as in much of the East, the ax and saw to join native stone in building sturdy houses, sheds and barns.

The homes these pioneer farmers built ranged from simple to elaborate, from the basic log or plank house to a relatively formal brick

A present-day owner pursuing renovations
in one of these old farmhouses may discover planks
hidden for decades under plaster or paneling.

farmers wrested crop and pasture land from deep forests. The slow, difficult clearing process yielded dark, rich soils. From early times, Chester County, for example, focused on agriculture, blazoning a plow on its first official seal dating back to 1683. The abundance of crops and cattle contributed substantially to the county's wealth from the time of the first settlers.

Early farmers, many of them Quakers, discovered a strong similarity to England's Cotswold country in the southern part of the county. Some 50 miles south of Philadelphia, they came upon a land of rolling hills and fields, clear streams full of fish and a plentiful sprinkling of dependable springs. Thick stands of chestnuts, maples, poplar and oak fell before

or stone dwelling. The beginnings were usually modest, with additions built as the family prospered and grew. The remnants of an isolated plank house built in 1648 testify to the courage of a settler who moved to the wilderness to clear land for farming. A plank house was similar to a log house but with the logs hewn to form flat surfaces on all four sides. Planks fit more tightly together than logs, requiring less chinking and were often plastered on the inside surface. A present-day owner pursuing renovations in one of these old farmhouses may discover planks hidden for decades under plaster or paneling.

In the Delaware Valley, where the Delaware River flowed through southern New Jersey,

(Right) The interior of a renovated stone farmhouse originally built around the late 18th century in Dutchess County, New York.

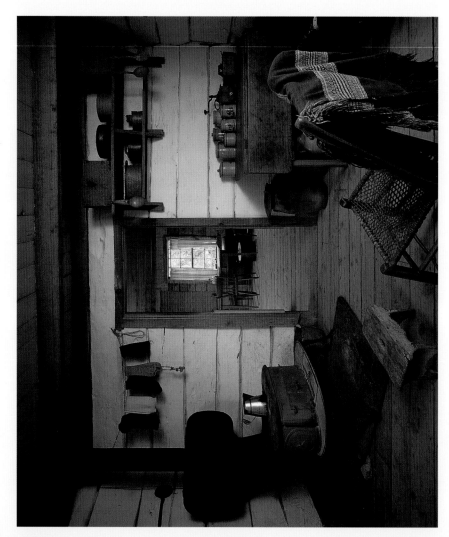

This room became the center of cooking, eating and daily chores. The typical huge fireplace could hold several small fires at one time for preparing different foods. It certainly served as the primary source of heat and light. A high masonry stove may have connected to the back wall of the fireplace, with a flue to conduct heat into the larger of the two main rooms.

In both German and Swedish settlements, as farmers prospered, half-timbered and then stone structures came to replace log and plank houses. Until stone became predominant, these building materials posed the ever-present danger of fire. As time passed, and owners changed, clapboards covered logs. Often the residents had no

Pennsylvania and southward into Delaware, the Swedes and Germans created quite different farmhouse designs. The Swedes were attracted to the good farming country. Their influence is especially obvious in the type of log construction, the evidence of ancient crafts and culture and the first appearance of corner fireplaces.

The Germans in the Delaware Valley built unique one-room log cabins, placing the fireplace in the gable—quite unlike the Swedish cabins. Eventually the one large room was sometimes divided in half and the fireplace placed against the middle wall, facing the smaller room.

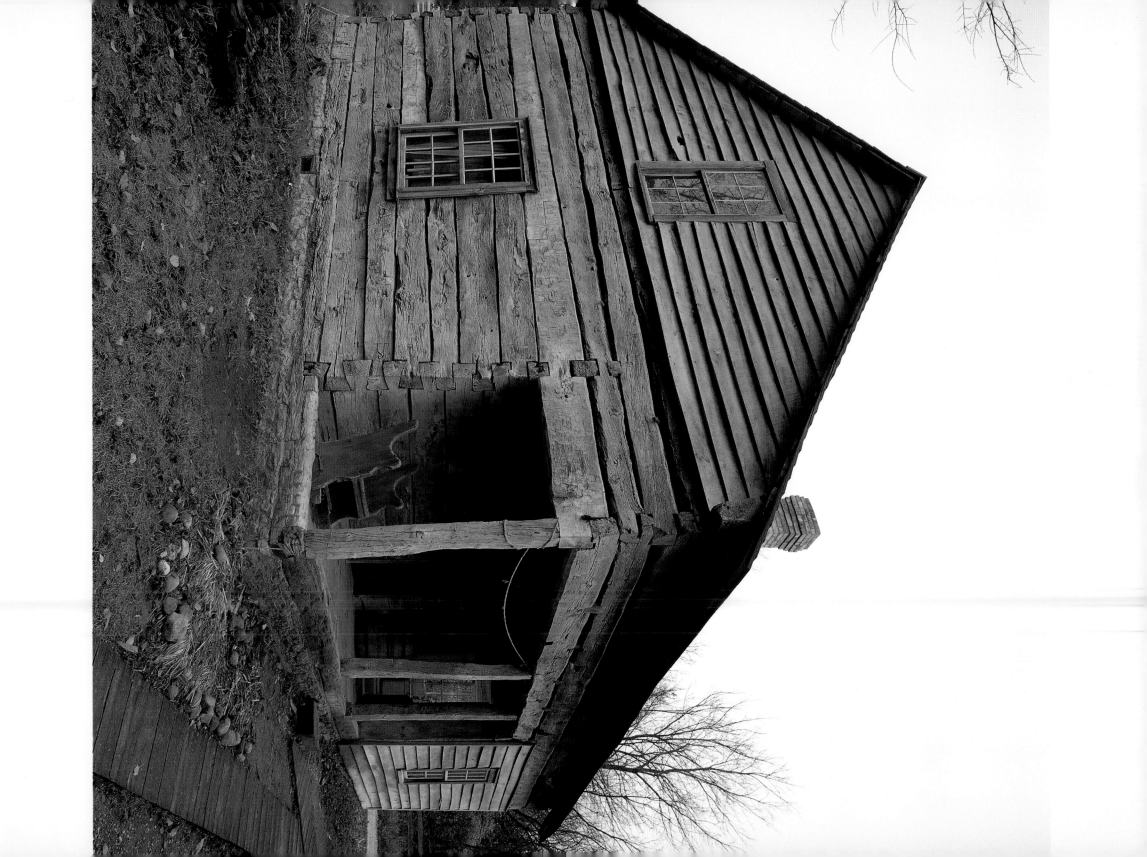

idea that a fire hazard existed—until a chimney fire erupted.

In Pennsylvania and in varying degrees as farmers pushed west, they changed from round to square-hewn logs for a tidier look that made for more warmth with less chinking. Houses and barns, too, were often built into a bank, providing a lower level that was cooler in summer and warmer in winter. Stone rather than logs were more common and also more enduring.

One of the oldest examples—built in 1719—is the Herr House in Lancaster County. Strong in German influence, it is built of fieldstone rather than quarried stone. The original workmanship was good, and successive owners have cared for it well. An unusual "double attic" with two floors tucked under the roof was an example of German thrift, providing space with less cost

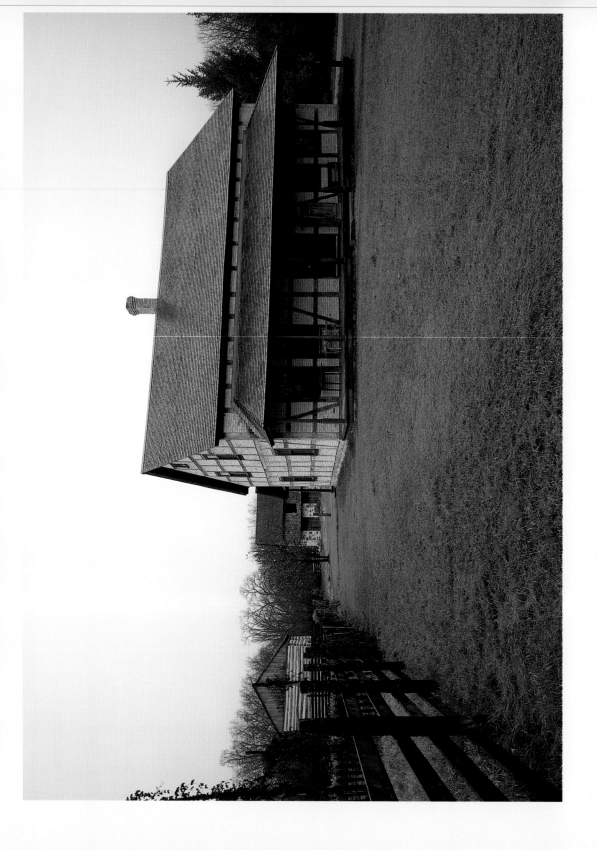

(Bottom) The Koepsell House, centerpiece of the 1880 Koepsell Farm in the museum's German area, was built in the Washington County town of Jackson, Wisconsin, in 1858 by carpenter and master builder Friedrich Koepsell.

than adding another story. The windows are small, since glass was scarce and costly. Shutters served a double purpose, for safety and to keep out the cold. In its day the house was considered a mansion.

A VISIT to one well-known log farm-house requires a trip to the Henry Ford Museum in Dearborn, Michigan. Originally built in western Pennsylvania, it belonged in 1780 to William Holmes McGuffey, whose book, *The McGuffey Reader,* was the text from which numbers of American children once learned to read. Dismantled and reconstructed at the museum, the house has a few odd features that defy explanation, such as an outside ladder to the loft, no doubt an extremely inconvenient feature in inclement weather. The ceiling beams are exposed and the inside walls are unplastered. The original furnishings, of apparently good design and carefully made, add comfort.

A carefully restored and maintained farmhouse is the pride of a couple near Mt. Joy, Pennsylvania. Built in 1819 of local limestone, Lime Ridge Farm will survive. The original owners are buried in a tiny cemetery on the farm, a continuing reminder that the history began here. A fifty-five acre game preserve and a conservation easement guarantee that future generations will enjoy the beauty and continuity of that history.

Conservation easements deserve more than a passing mention for their value to those who care enough about the farmhouse in its natural setting to want to protect its future. Easements preserve natural resources, open space and the farming community. Where pressure for development is heavy and developers offer astronomical sums, preservation decisions become dramatic.

Briefly, a conservation easement donor contributes all or portions of the development rights for the property to a land trust that holds them in perpetuity. They can never be used for building purposes, and the gift provides public benefit by conserving natural resources, watersheds and scenic views.

Just as old farmhouses are an endangered species and deserve preservation for future generations, the accompanying natural resources need to be preserved as well. Otherwise the ability of the land to meet the needs of the population will eventually be lost.

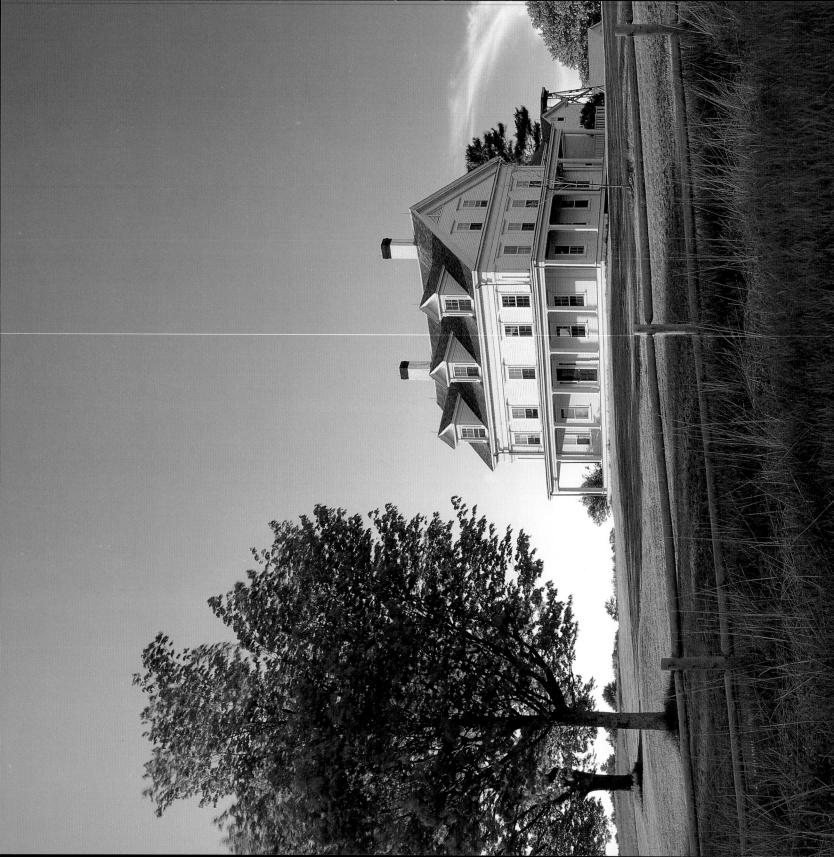

How Farmhouses Evolved

WHETHER THE FOCUS is New England, the Midwest, the South, Far West or north into Canada, there are similarities in the patterns of settlement and change.

Economical, frugal farmers built relatively simple farmhouses. Yet in many ways these structures exhibit more intrinsic beauty and dignity than many of today's expensive, often ostentatious mansions.

A farmhouse often changed with the years and subsequent owners. In Lancaster County, Pennsylvania—a treasure trove for farmhouses because of its continuing viable agricultural economy—the Martin farm is now 100 acres instead of 259. It reveals an interesting lesson in the evolution of design as the sum of cultural contributions. This is a working farm, sustained over generations by large families working together. Clearly the original builders were German or Pennsylvania German—(not Pennsylvania "Dutch," a corruption of Deustch).

An 1805 date stone appears on a section of English Georgian design, but the original style is older. A center hall runs from front to back with two rooms on each side. A large, simple fireplace dominates the back room on the left and

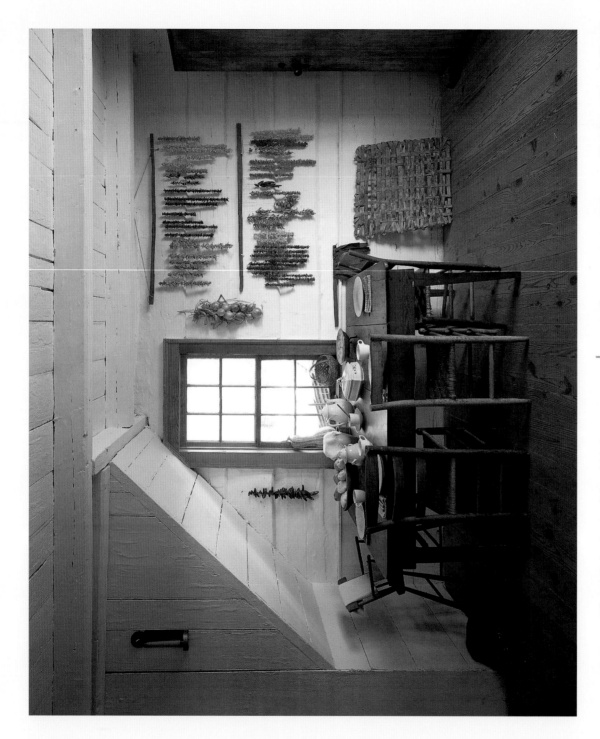

includes trim, a mantel shelf and a crane for holding pots.

The door indicates protection against marauders—Indians or others with less than benevolent intent—with glass on the upper half (a sign of wealth) and a panel that slid up to cover the glass. This panel served a dual purpose as a storm window in winter. A large cellar extending fully under half the house provided storage for fruits and vegetables. A summer house and some later additions don't quite match and may not be as carefully crafted as the early construction—a notable example being the front porch. The outbuildings are solidly built and include a huge barn. The entire complex is unusually fine. Legend has it built by a Mennonite, which raises speculation since Mennonite houses were

(Above) Notice the simplicity of this farm kitchen, part of the Museum of American Frontier Culture in Staunton, Virginia.

generally of modest size and design.

Descriptions from archives, sales and auction notices offer clues that make it possible to create a fairly clear picture of the families, styles and materials that produced some of the more

> There was no central heating until the early 1960s.
> There was a time the owners well remembered when a hot
> shower was the epitome of luxury.

venerable farmhouses. For example, one small stone farmhouse built in Pennsylvania in the early 1700s was a family's first home on the new land. Well-protected from the wind and close to a ready supply of firewood for the walk-in fireplace, it featured an attached frame kitchen with its own fireplace and, later, a cookstove. The farmer built the cellar around a spring that remained ice-free all winter. The downside of indoor water was a house that never quite dried out.

Crops grew well, the cows produced plenty of milk, and the farmer managed to put some money aside. In 1834, he hired carpenters and masons to build a large two-story brick house. It was a fine structure with paneled doors, handsome trim and mantels and a large beehive oven. The kitchen was the heart of the home, especially in winter when it was the only heated room. At night children and parents alike hurried from the glow of a hot stove to dive between flannel sheets and pull heavy quilts up to their chins. Rising in the morning was a reluctant exercise that only sounds romantic in a novel. There was no central heating until the early 1960s. There was a time the owners well remembered when a hot shower was the epitome of luxury.

Five generations traded houses back and forth as the family size ebbed and flowed. A tradition developed that a good farm is for growing crops, not houses. Sons went off farm for their first young-family homes, returning when housing was available. That return has been supported at times by "recycling" old ruins on the property, filling the shells with new construction.

Traditions were important in a farm family's existence. Farmers might build a house for a

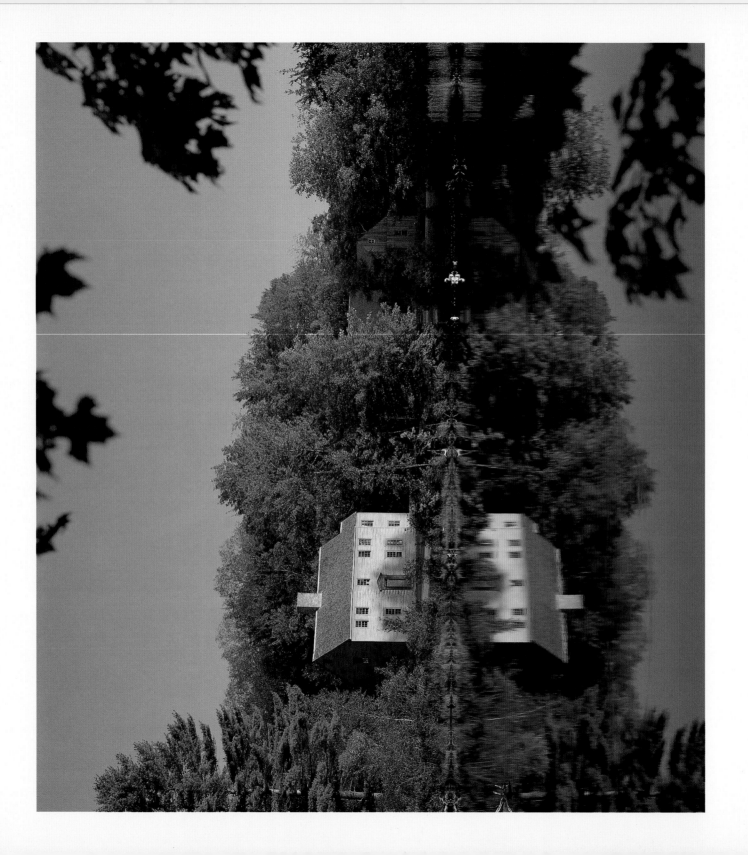

(Top Left) This lovely lakefront home is in Standish, Maine. The salt box house was originally built in New Hampshire.

(Right) A basket of apples sits invitingly on a table inside of the salt box house.

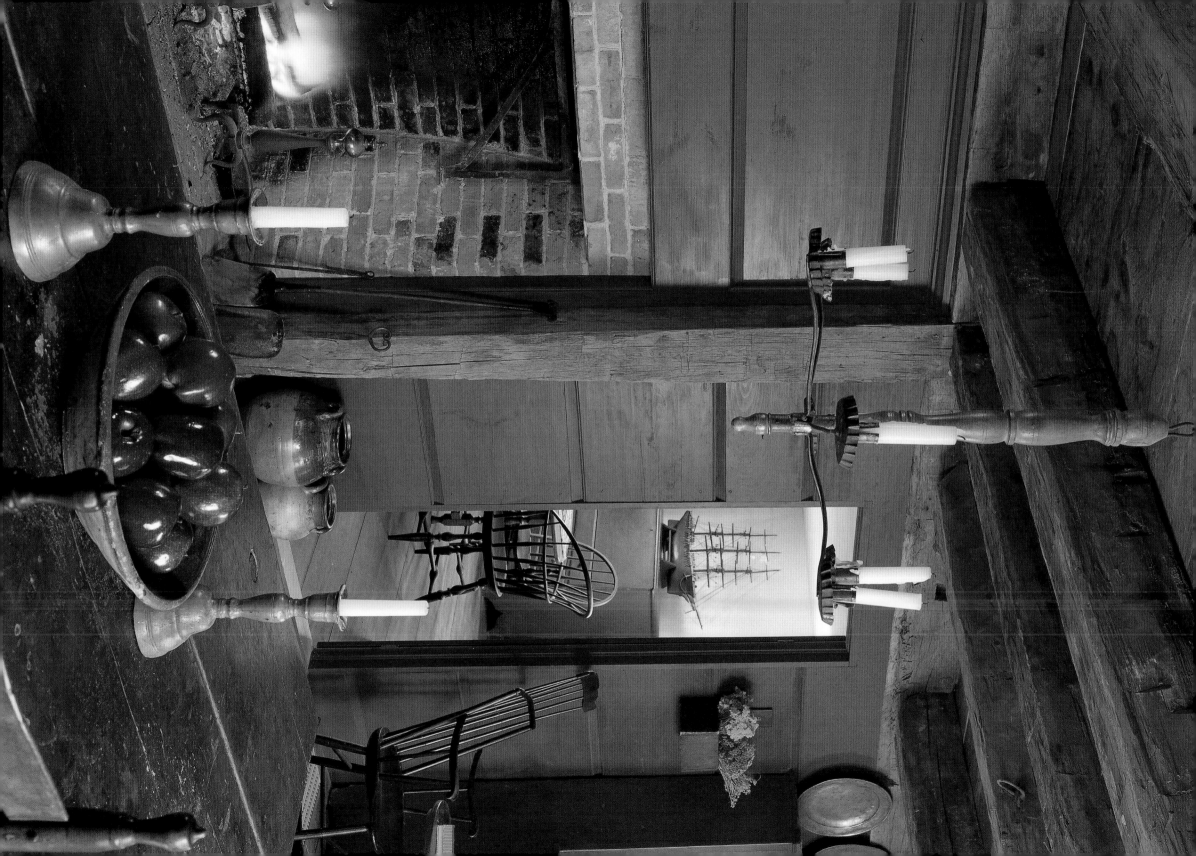

The Farmhouse

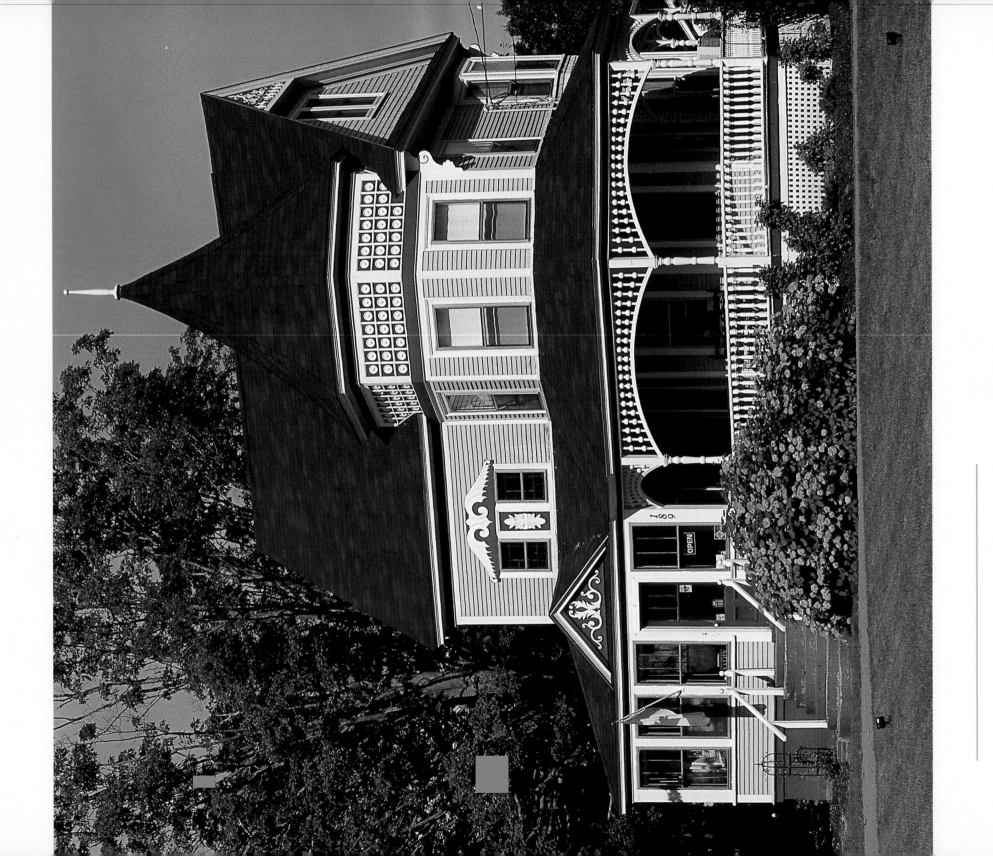

(Top) This eye-catching *Victorian* home was built in the mid to late 1800s in Bridgetown, in Nova Scotia. Canada.

grown son or daughter, or perhaps in depression time sell off acreage to a country gentleman.

However, most land remained in the family as long as there were children and grandchildren to till the soil and milk the cows. For today's farmers, the greatest challenges may lie ahead as developers look ever farther from the cities for places to grow houses rather than crops. "Sprawl" or uncontrolled growth threatens farms and, when a farm is sold, the old farmhouse may disappear.

P ENNSYLVANIA, as the largest Middle Atlantic farming state, became an important way station for the export of housing design as the population moved west. Settlers traveling from the East Coast tended to cross the state slowly, stopping for months and even years on the journey west, adopting the designs and methods of building along the way. Some became accomplished carpenters and masons, and the houses they built reflected their skills.

In the immigrant-heavy settlements close to Canada, farmers re-created the cultures left behind, at the same time that they were eager to adapt to a new country and environment. German brick houses, where family life centered around

kitchen and church, can be found in Minnesota's Stearns County and other areas. The Norwegians' solid, prosperous looking wooden farmhouses in North Dakota exhibited a sense of competition in exploring architectural individuality.

Concurrently with settlement activity in the United States, Canada's contributions to farmhouse history displayed abundant similarities to and some differences from American examples.

The ubiquitous log home, arguably the best known settler dwelling on the North American continent, appears everywhere that the raw materials exist.

Better homes appeared among the more prosperous farmers, ranging from simple but substantial frame houses and outbuildings against the background of the seemingly limitless plains in Saskatchewan to a cozy farmhouse in Brandford, Ontario that added Victorian pierced panels and gingerbread to a rather simple cottage design.

In contrast to the more familiar, very simple houses, a rather fine farmer's house in Upper Canada sported shutters, a handsome wraparound porch and landscaping with trees of decent size. Even in the Ontario countryside, brick was a common building material among

neighbors to the south. Tom Cruickshank, writing in his Old Ontario Houses: Traditions in Local Architecture, suggests that it is time to "give it [this type of house] a proper name: the 'Ontario farmhouse' style."

Reflecting the multicultural influences, the Scottish crofters or tenant farmers of Canada built their traditional stone huts while the French immigrants adopted the building technique that came to be known as Red River Frame or Hudson's Bay Company Frame. These sturdy buildings, many in use today, were dressed

timber frame structures filled with horizontal logs spiked together with long nails at the corners (the ends didn't overlap like the more familiar American log cabins). The builders chinked the spaces between the logs with a plaster made of

the farmhouses. The preferred design was a story and a half in height with doors and windows arranged symmetrically. A gable peak with a Gothic-pointed window, like the dormers in a Cape Cod cottage, expanded the usable space. With less than two full stories, the tax assessor was kinder in issuing his bills. This style developed in Ontario and is considered as typical of its place and time as the New England saltbox. It also expresses an inborn conservatism than is characteristic of the settlers in Ontario, who did not share the revolutionary philosophy of their

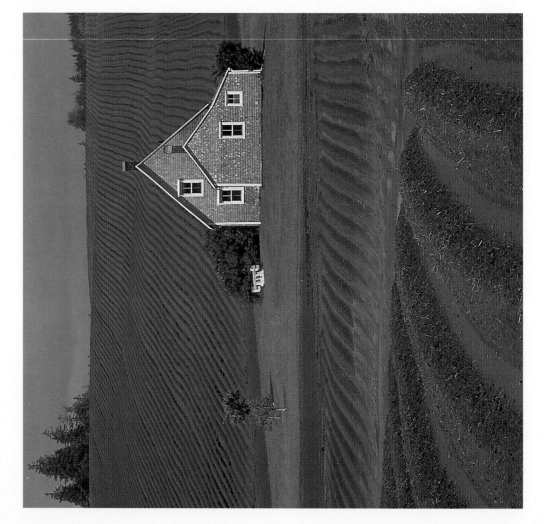

(Bottom left) Freshly plowed potato fields and farmhouse in Long River, Prince Edward Island, Canada.

(Right) A well adorns the grounds of the Silverbush house in Park Corner, Prince Edwards Island, Canada.

(Overleaf) The Thompson-Neely House in Washington Crossing State Park, Pennsylvania was one of three places used by General George Washington to plan his Christmas night crossing of the Delaware River.

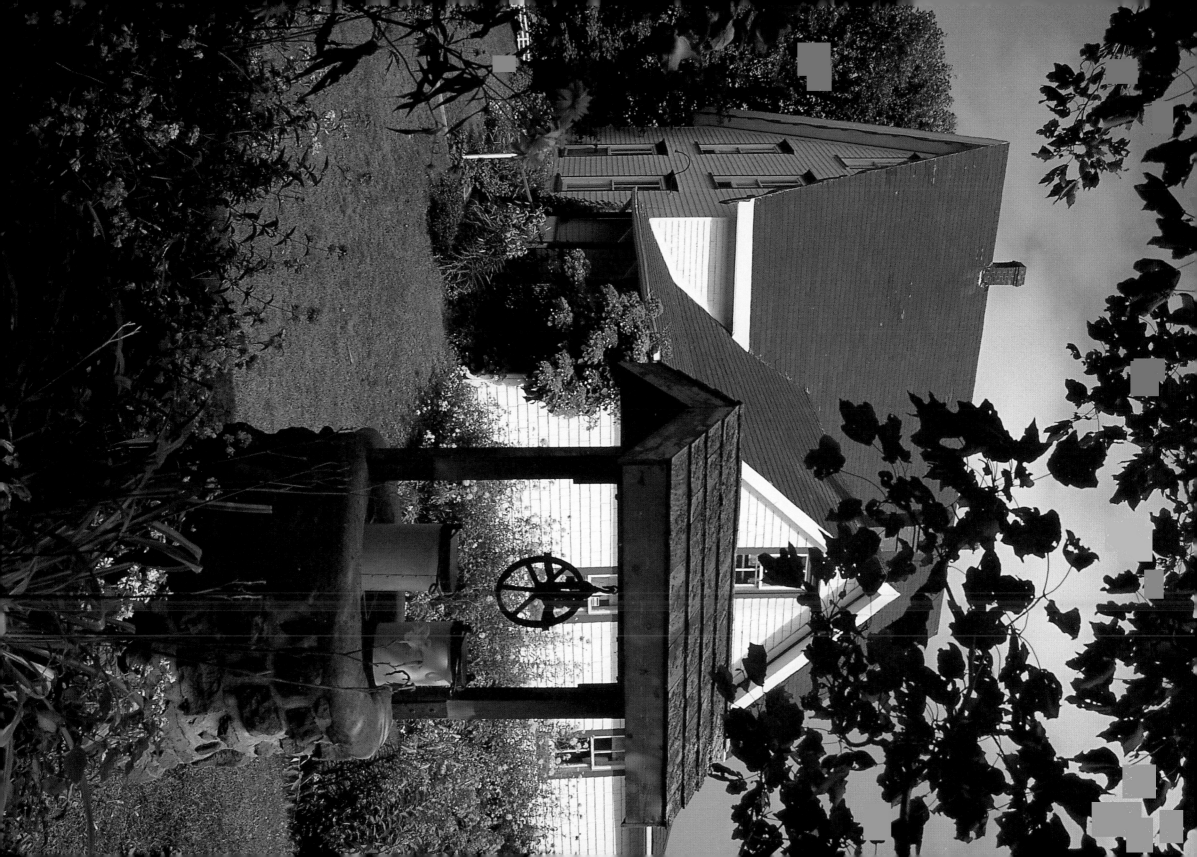

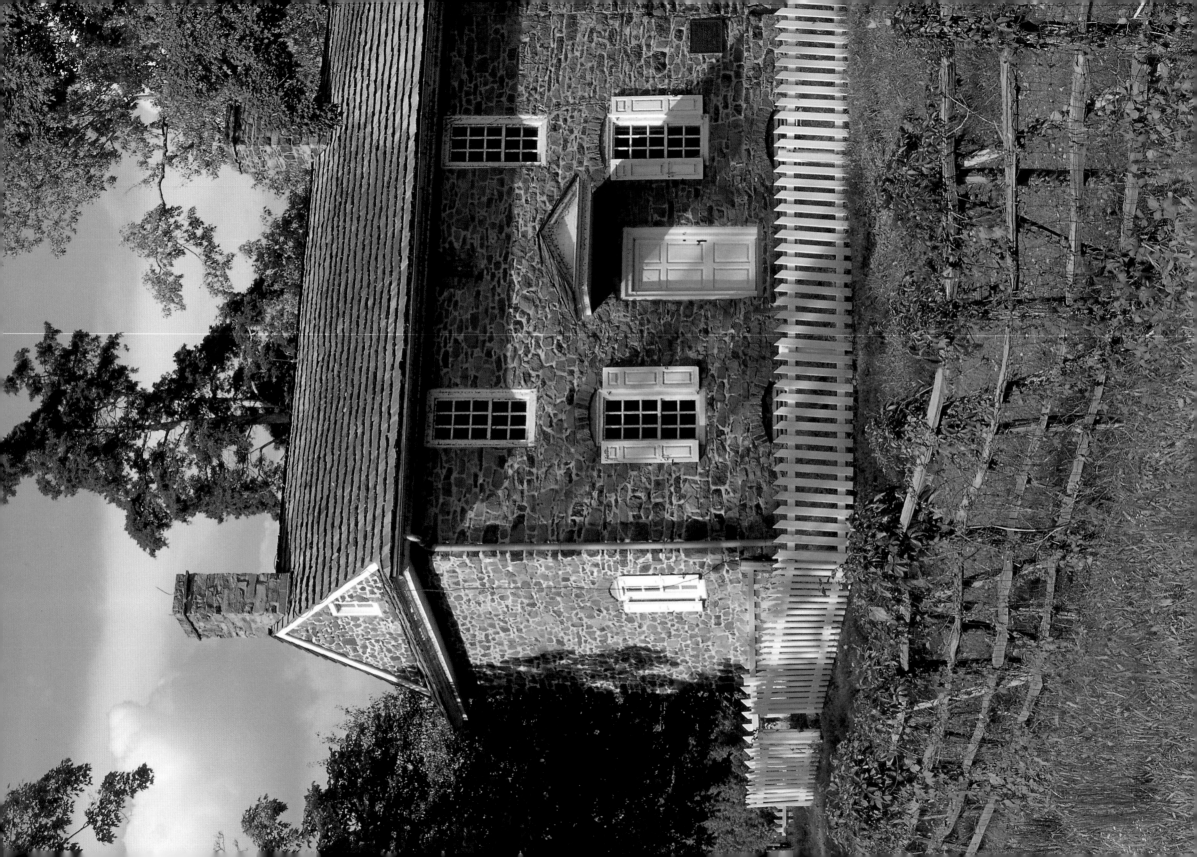

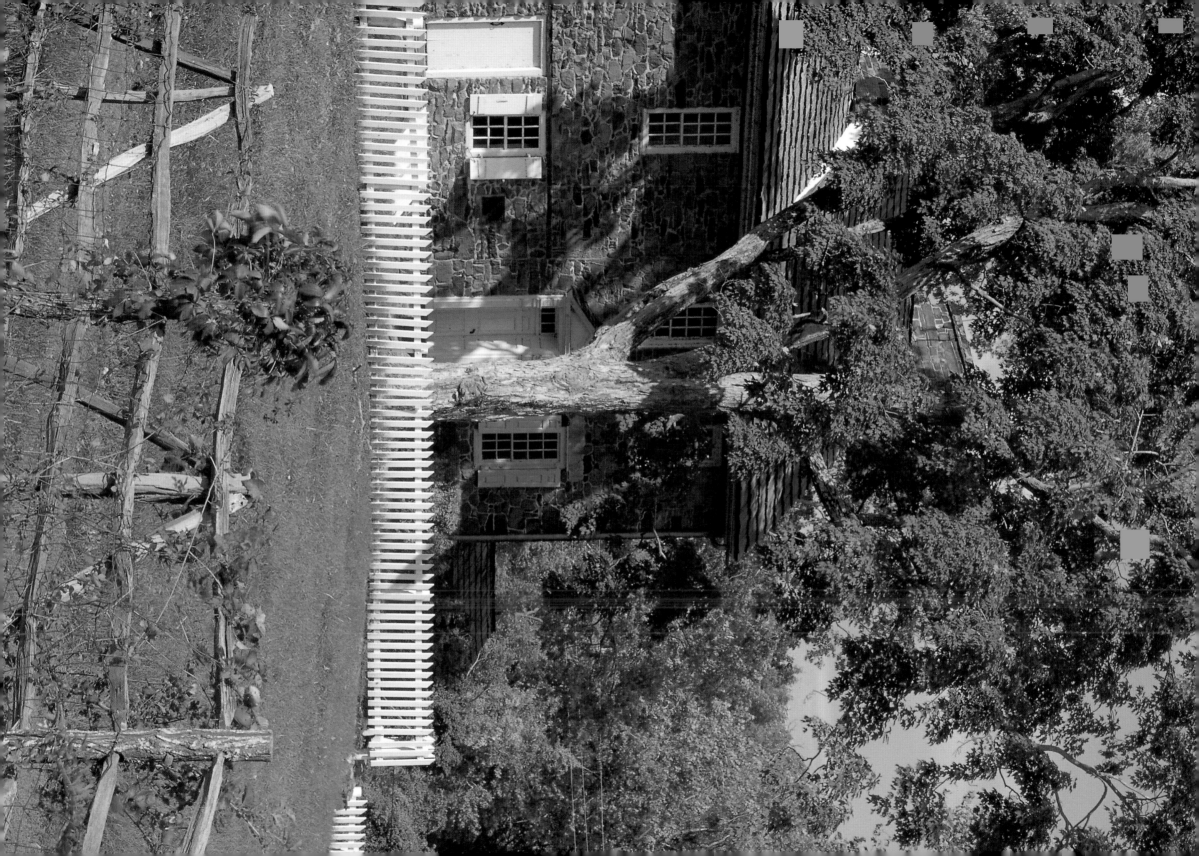

Ontario dwelling is the stuff of dreams."

All across the United States and Canada, there are thousands and thousands of simple farmhouses, perhaps millions, for who could hope to count them with any accuracy. Built by the farmers themselves and their families, these utilitarian homes may range from crude to meticulous in their construction. They have often been expanded to include subsequent generations.

This is especially true in the case of the Amish who no longer live solely in Pennsylvania, but may be found in Ohio and other states to the west and even south as they continue their search for expanses of affordable land to sustain their traditional lifestyle.

Wherever they go, the Amish will build substantial farmhouses, but first and foremost it is the barn that is the heart of their farms. Simple houses, imposing barns, a windmill to pump water and no electric lines. One can easily identify those houses.

> They called these houses "soddies."
> Shelter they were, cool in the summer and warm in the winter, but dark, damp and uncomfortably hospitable to insects.

clay, straw and mud. Traditionally, they coated both the outside and inside surfaces with mud plaster, although by the 1880s, board siding was more common.

The plains of Canada, as in America, lacked trees for either logs or plank houses, so the settlers cut and layered sod in much the same way as bricklayers would do. They called these houses "soddies." Shelter they were, cool in the summer and warm in the winter, but dark, damp and uncomfortably hospitable to insects.

Similar to the renewed attention in rescuing and restoring old farmhouses in the United States, the disappearance of many of the older ones has called attention to the urgency of saving them. In Canada, too, "progress" has traded new development for historical context, as in the large swath between Niagara Falls and Toronto. Fortunately, according to Cruickshank, public opinion has been aroused and "there is a whole new generation of enthusiasts for whom restoring an old

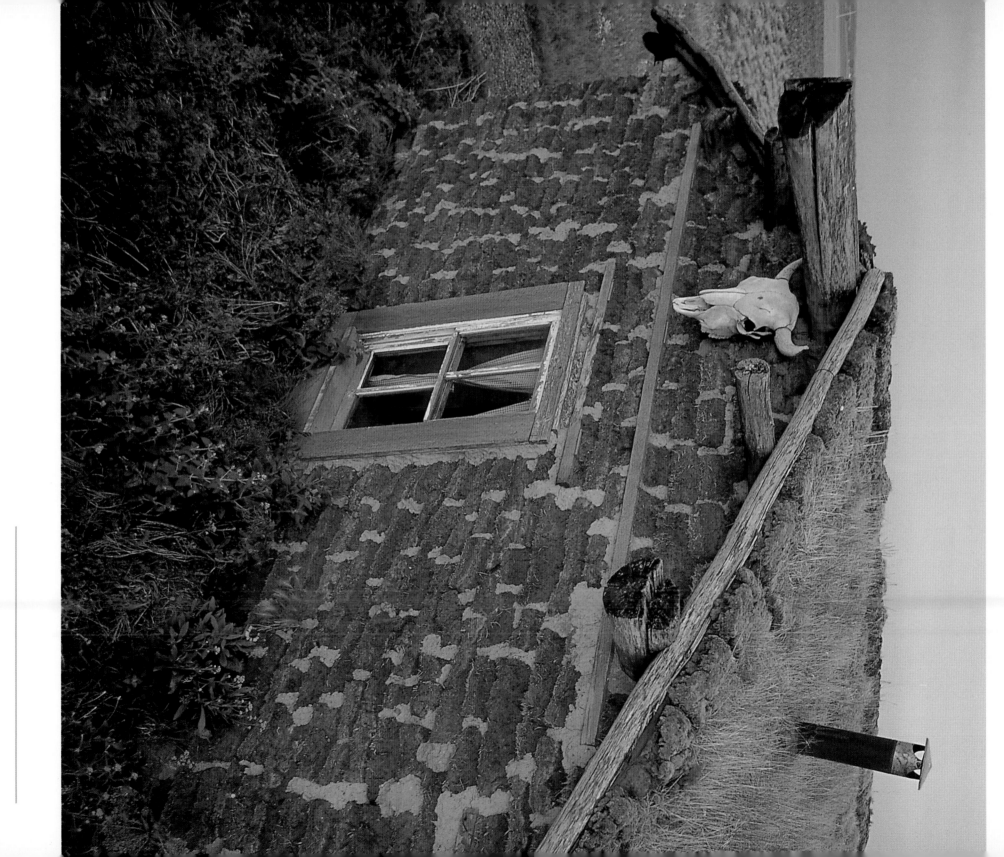

(Right) McCone's Sod House, near Sanborn, Minnesota, provides a unique example of a well-built and well-furnished pioneer dwelling.

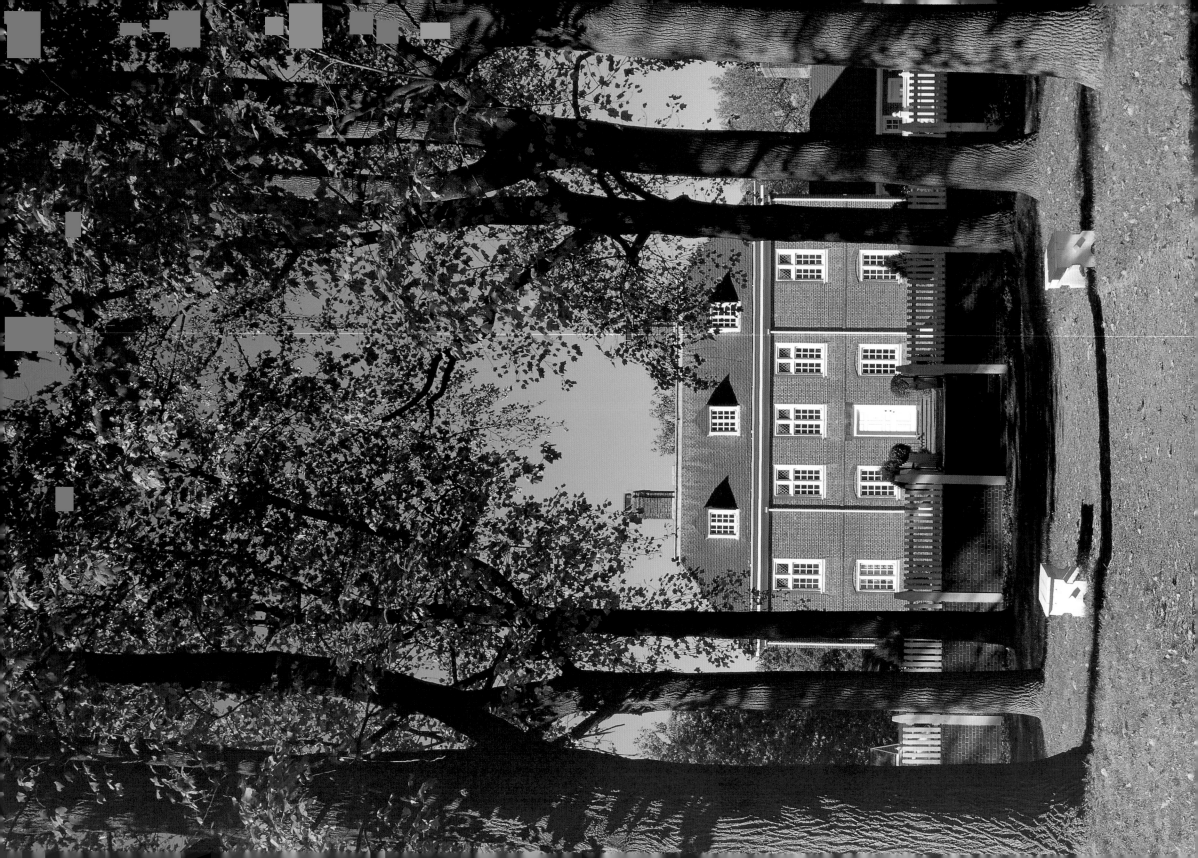

The Plain
and the Fancy

ANY HOUSE, LARGE OR SMALL, can be a farmhouse depending upon its location and its use. In most instances, geography determines the basic style. New England's Colonial style emerged in Massachusetts, propagating itself in large and small adaptations throughout the northeastern states and into part of Ohio, Illinois, Indiana, Michigan and Wisconsin by settlers from there and northern New York state.

Virginia's Georgian brick homes originated the southern Colonial style and spread south, dictating the imposing, white-columned high-

ceilinged homes that speak of elegance, servants and a gentleman farmer approach to agriculture. Plantation houses, among them those on the South Carolina Sea Islands, are not necessarily grand homes. The riverside plantations depended upon the water as an important highway, for social contacts and especially for carrying the valuable cotton crop to market. In this climate, too, porches and piazzas were important in providing shade for the hot summers.

The coastal states exported a wide range of styles to Kentucky, Tennessee and the other states to the west and south. As different national

(Left) A front view of Pennsbury Manor, the recreated country home of William Penn, in Morrisville, Pennsylvania.

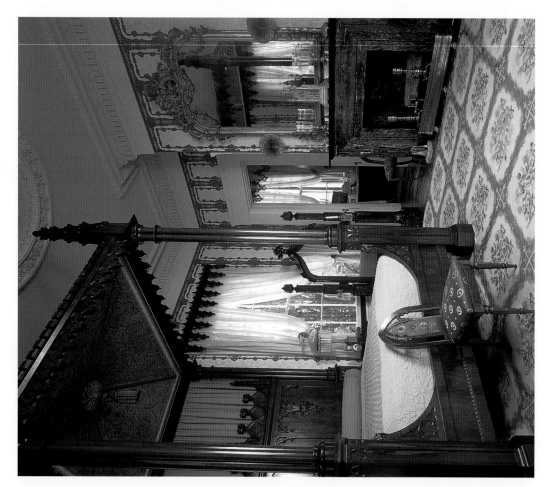

Palladian villa is one familiar to most Americans—George Washington's Mount Vernon.

Housing design became an important, informal export, especially in Pennsylvania. As settlers from other states and go-west Pennsylvanians spent time there, they adopted and adapted the architectural elements preferred by the English, Germans, and Swedes.

GEORGIAN HOUSES first appeared in southeastern Pennsylvania, supported by the plentiful supply of red clay that produced high quality bricks. They evolved during the Revolution into a more severe, classical style known as Federal. The Federal style lasted about forty years when enthusiasm for the Greek Revival house began to supplant it.

groups were attracted by the milder southern climate, they brought with them influences from their native countries that adapted well in the new locations. In North Carolina alone, specific settlements reflected the preferences of Virginians, French Huguenots, German and Swiss, while the farming activity often centered around tobacco. Tobacco would take the place of the elusive treasure that the early Virginia settlers sought, bringing fortunes to the plantation owners, many of whom built elegant mansions of Georgian and Palladian design. A prime example of the transition from modest farmhouse to

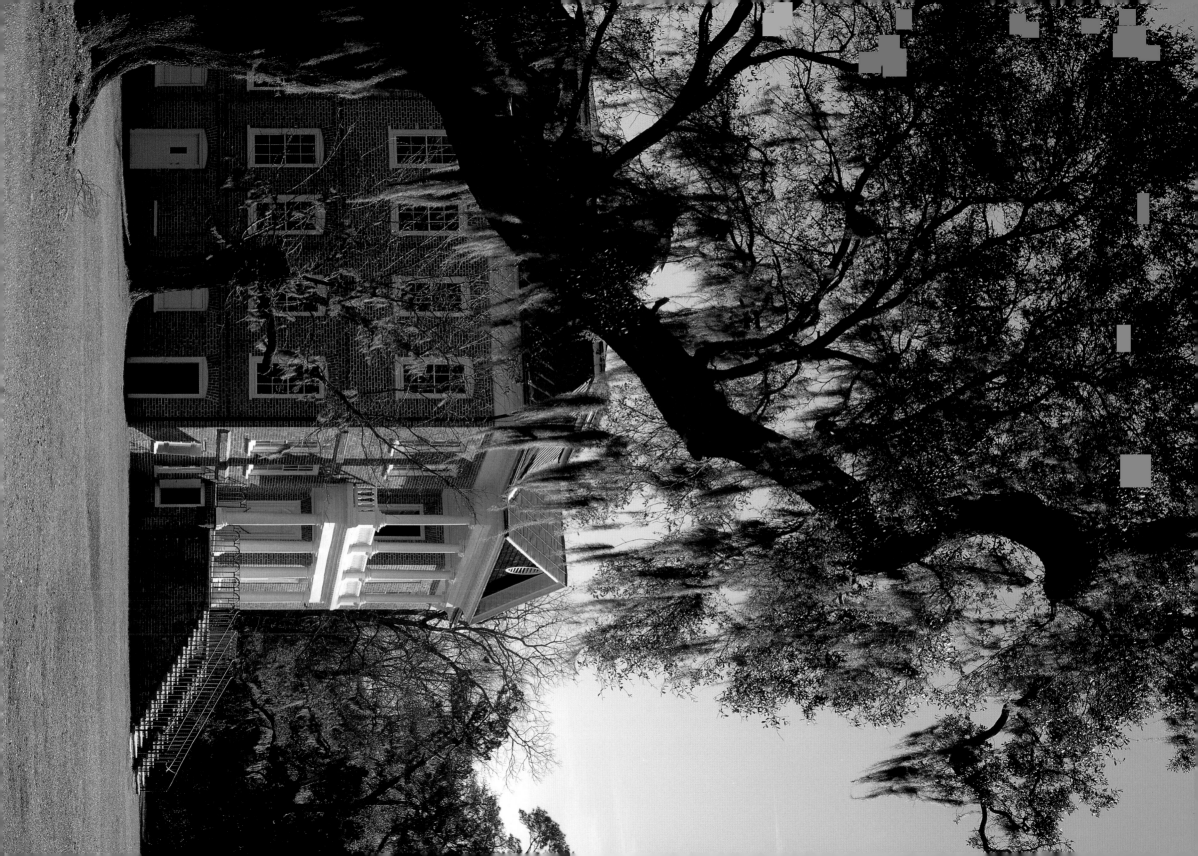

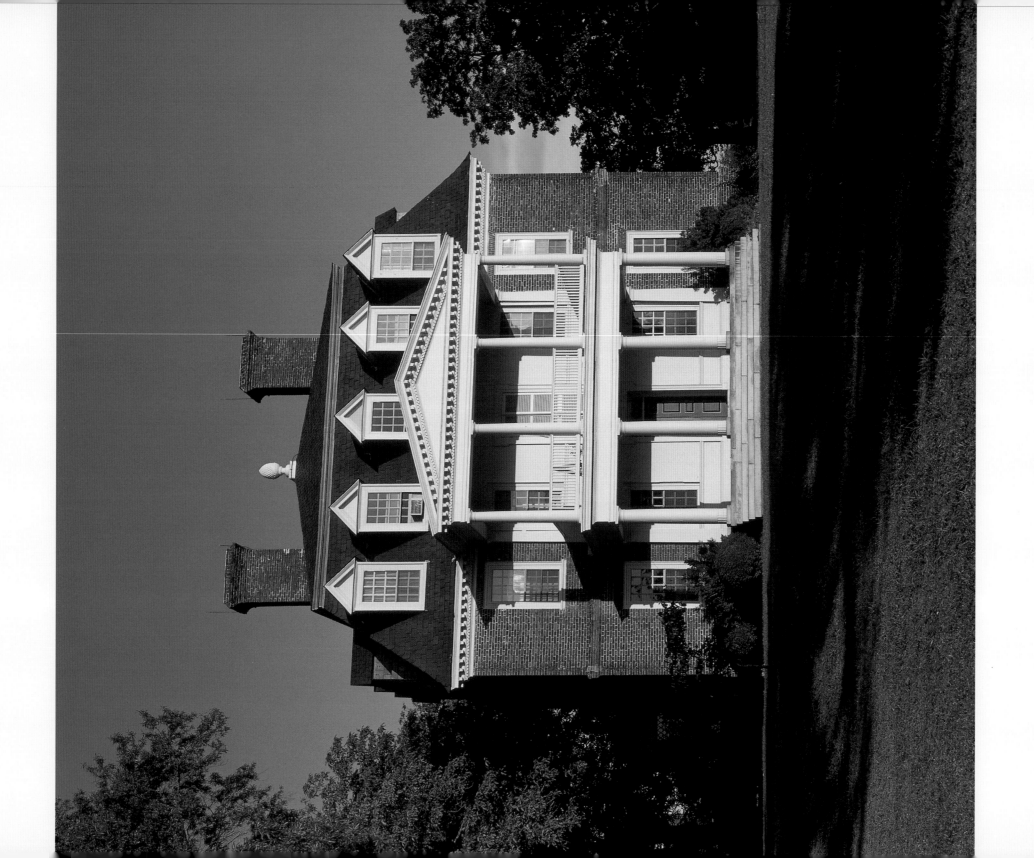

Greek Revival was considered the first all-American style—essentially "the expression of Greek classical design in terms of the new republic." Initially, Greek Revival public buildings tended to be monumental, but when trans-

central heating and insulation. Greek Revival design was to work its way all across the country, reaching California, Oregon and Washington in both large, elegant homes and formal public buildings as well as

Tobacco would take the place of the elusive treasure that the early Virginia settlers sought, bringing fortunes to the plantation owners, many of whom built elegant mansions.

lated to small houses, especially farmhouses, the classical elements of pillars, roof pediments and porticos became perhaps pretentious. A recurrent design decision seemed to focus on whether the gable end or the main facade was the appropriate "front" of the house.

In exploring very rural upstate New York along the Schoharie River, the number of Greek Revival farmhouses is quite amazing—large, small, some of them barely cottages—but all with the classical themes intact. For instance, two elderly bachelor brothers, lifetime beekeepers, live in a handsome example on the main street of a small town that boasts the longest covered bridge in North America. The house has not been changed much over the years—it lacks

smaller houses. In the Midwest the interpretation of Greek Revival tended to be more restrained until around 1840, when Victorian Gothic decoration began to appear on existing houses. To the confusion of old house enthusiasts in years to come, even early fully American homes in New England, Virginia, Pennsylvania and the southern states, often had pediments and corner pilasters—the trappings of a Greek Revival house—superimposed over simple lines.

Fashions in houses may not change as rapidly as those of dress, but in turn Greek Revival gave way to the Gothic Revival movement in the United States (approximately 1800–1880). The fascination with Gothic design reflected a romantic movement in literature and

(Left) The Shirley Plantation, in Charles City, Virginia. The home is recognized as an architectural treasure.

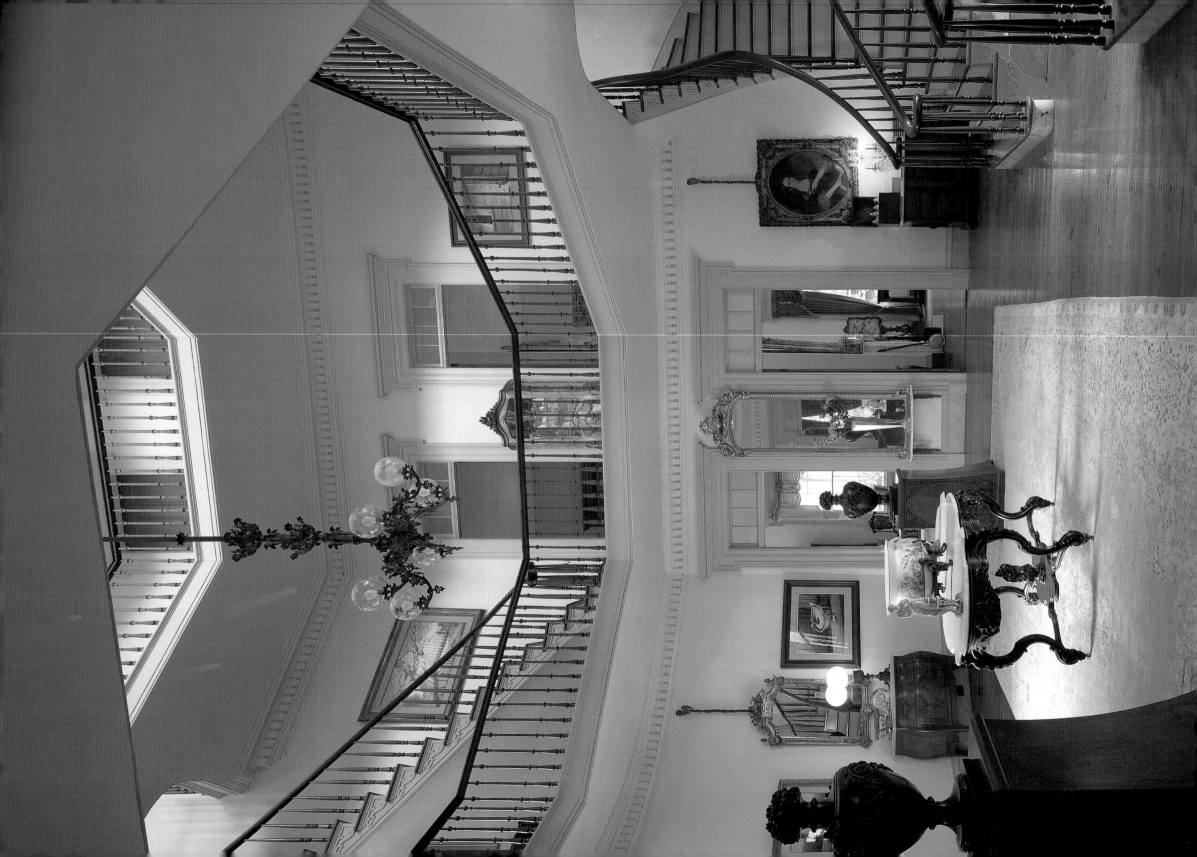

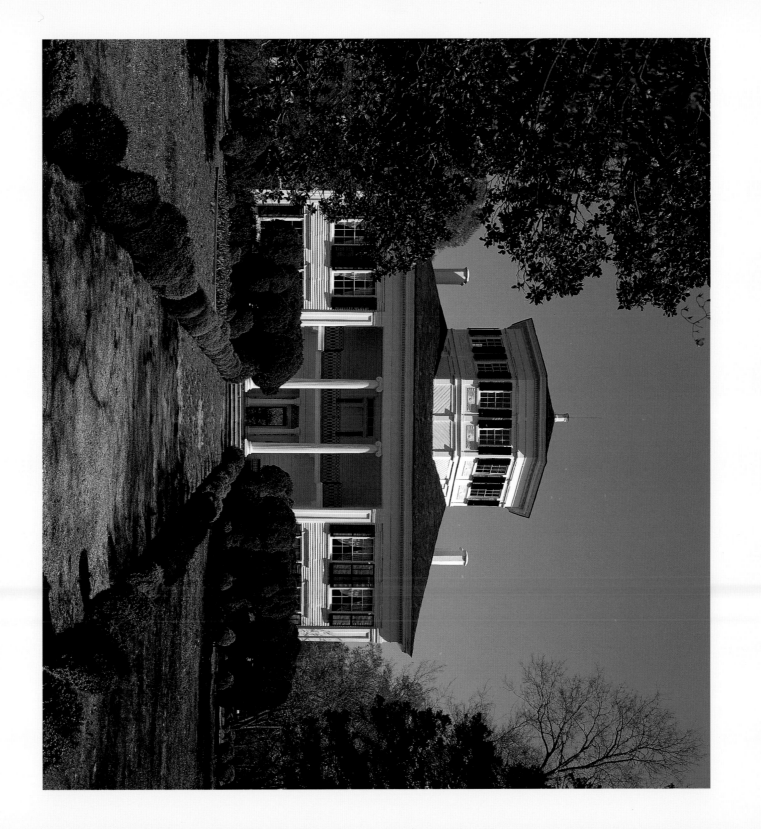

(Left) A beautiful chandelier graces this foyer of the Waverly Plantation in Columbus, Mississippi. This showplace is one of the most photographed houses in the South.

(Right) The outside entrance of the Waverly Plantation, a National Historic Landmark.

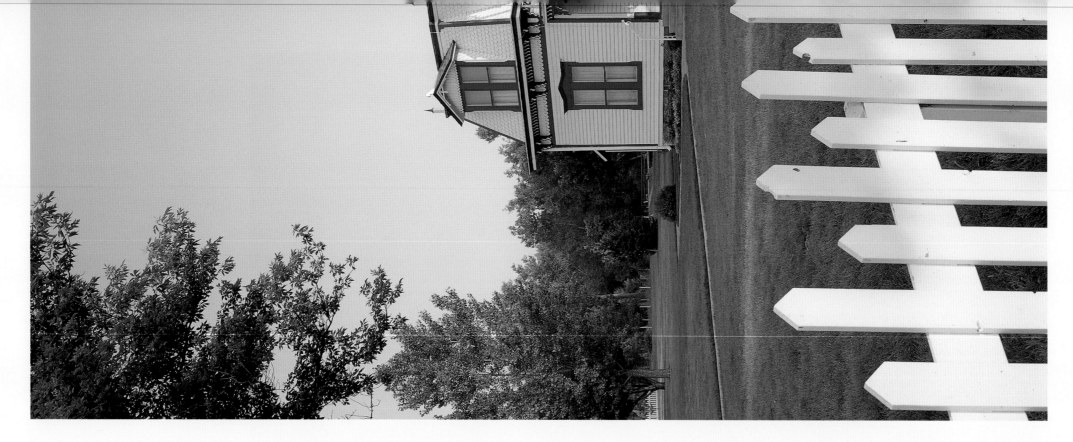

art that produced soaring towers and arches, often combined with carvings, sculptures and stained glass windows. Local carpenters and craftsmen did not design these houses and those of the Greek Revival: generally architects did. These styles overlapped one another in their time frame, and various architectural features may be found on any one or all of them.

THE GOTHIC HOUSES were virtual magnets for Victorian decoration. Victorian houses, on and off the farm, owed their existence to the Gothic Revival and the development of water- and steam-powered sawmills and nail-making factories. There were no limits to the complicated additions that could be manufactured, and sometimes it was difficult to identify the underlying style beneath the gingerbread. Late Victorian houses seemed to vie with one another in collecting wrap-around porches with turned spindles, festoons of wooden icicles, cut-out brackets —and if the farm family was truly prosperous, it proudly displayed an upright piano in the parlor.

With so much design overlap it is difficult to separate the periods with sharp definition.

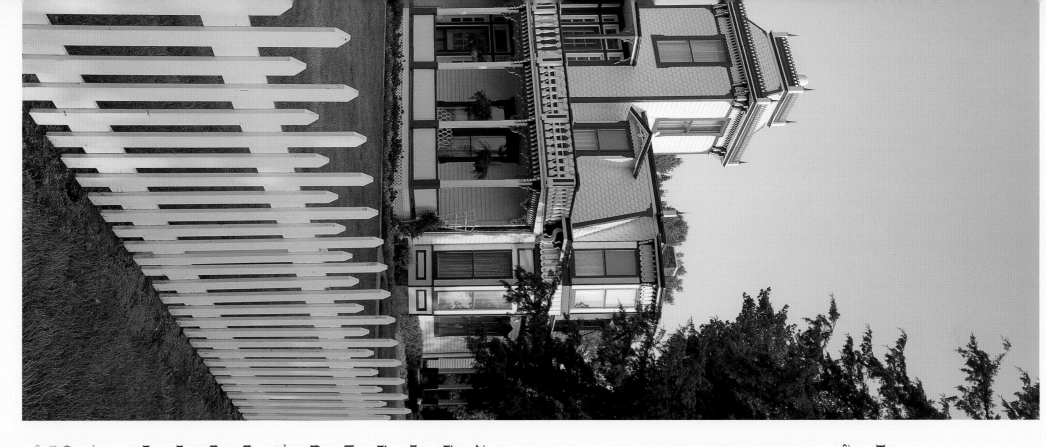

However, approximate dates may be assigned as follows:

Late Colonial	1700–1720
Early Georgian	1720–1760
Late Georgian	1760–1780
Gothic Revival	1800–1880
Federal	1780–1820
Greek Revival	1820–1850
Early Victorian	1830–1850
Late Victorian	1850–1900

By 1886, the records showed that there were 2,033,655 farms encompassing 405,280,851 acres in the United States—and that didn't include neighboring Canada where farming was equally important, especially along the international border. Farmers were mostly self-sufficient and farming shared importance with manufacturing. There was some migration to the cities, but it took cataclysmic events like war and depression to move people away from the farms in large numbers. World War I, the advent of the automobile, and heavy, costly dependence upon the

(Left) Buffalo Bill's ranch in North Platte, Nebraska, was built in 1886 in anticipation of his retirement as a farmer.

ACROSS THE STILL MAGNIFICENT VISTAS of the middle and far West, a farmhouse set amid hundreds or thousands of open acres is hard to miss. However, you can find farmhouses everywhere, from thickly settled towns that have swallowed up old farms to housing developments where the developer had the good sense to preserve historical context. Farmhouses survive across the country, from New England villages, to mountain roads of the West and old mission properties in California where thick-walled adobe farmhouses sit solid and cool under the hot sun. "Farmhouse" is the context in which a house exists, the purpose for which it was built. The use may change, but the history lives on, and half of the pleasure is discovering it.

railroad for transportation of grain crops each contributed toward the ebb and flow of farm fortunes and misfortunes.

The Depression of the 1930s and the wrenching experiences of the Dust Bowl dealt hard blows to the proud, independent spirit of the farmer. Pride was an important component of the farming community, yet hardship dogged the steps of the sharecropper, as well as the Okies migrating with all their goods piled in old pickup trucks and jalopies—driven from their homes by the dust. The tenant farmer never seemed to catch up with each spring's planting loan. The small independent farmer leased more land and dreamed of owning it all. Yet the fact that these were family farms often made it work. Large families worked together, found strength in their numbers.

Not all houses with a typical farmhouse plan and construction are indeed farmhouses. In the more thickly developed suburbs along the coasts, along the major rivers and around the Great Lakes, such houses may have an existence more closely connected to town than country. Until the arrival of the automobile, substantial homes in any community claimed a barn or carriage house to stable horses, with at least a small paddock and a loft large enough to store hay and feed.

(**Right**) The gracious entrance of the Oak Alley Plantation, a Greek Revival-style mansion in River Road, Louisiana.

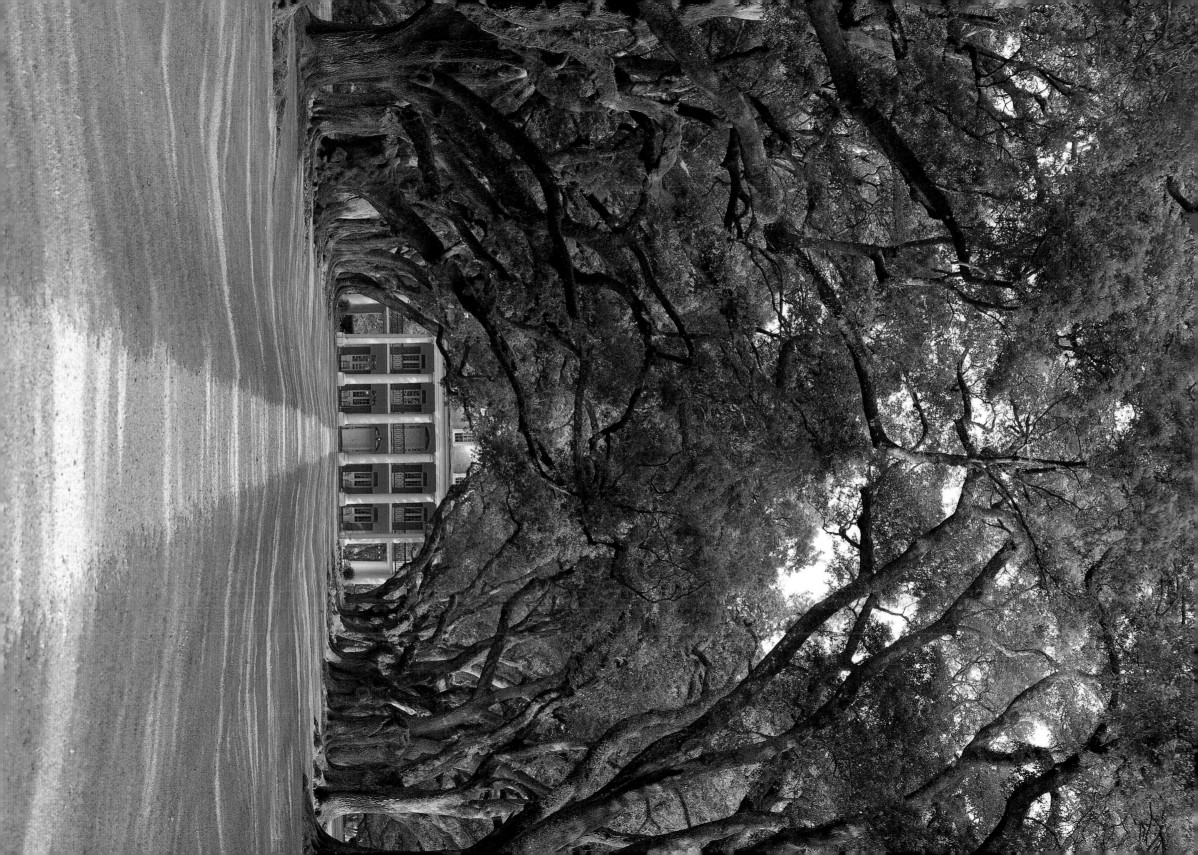

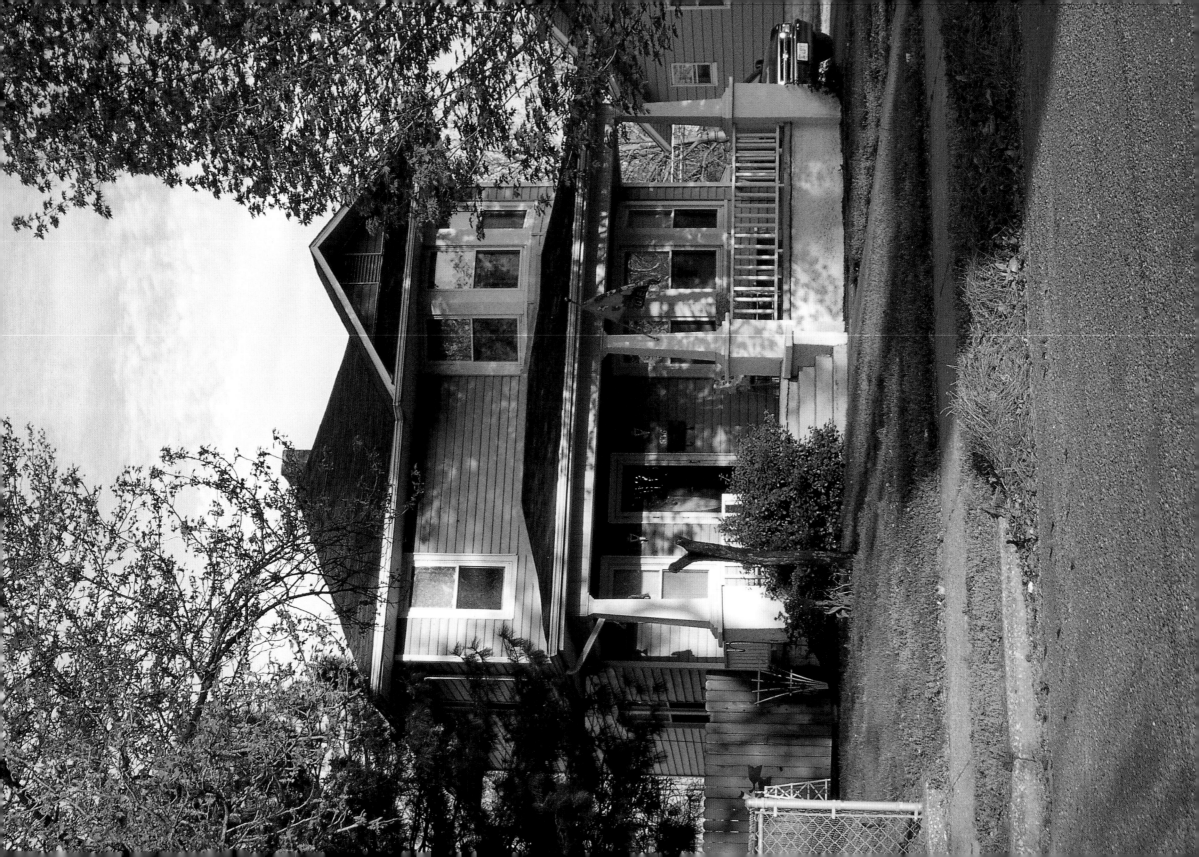

What Sears, Roebuck Contributed to Rural America

A SEEMINGLY UNLIKELY BUT thoroughly American category is the houses from Sears, Roebuck and Company. Those homes, remarkable values at the time, arrived in boxes, ready to assemble. The designs are easily recognizable, even when you aren't expecting to see one, such as a model that turned up ten years ago on an empty lot among a hundred years of housing stock. Just a little single-story bungalow, a tiny house really, with a full-width front porch. It was a model familiar in towns and on farms all over the country. Although precut, the homes were built on a

warm and human scale, befitting small-town farming communities—where, naturally, we might expect to find old farmhouses.

Denizens of small towns and farms alike treasured their Sears catalogues as the country was settled. Distant from sources of supply, homestead families—especially the children—dreamed over the pages. Take the wish list one step further to think about planning and buying a house from the catalogue. Imagine a family poring over the plans, matching them against money saved, investing years of serious thought to the order—and then the commitment and excitement

of finally sending it on its way. *Houses by Mail*, a fascinating little book, describes hundreds of these durable examples of American ingenuity.

One Sears house sits high in the south central Colorado mountains, altitude: 8600 feet, where Germans immigrants settled Pine Creek Ranch around 1880. A 1929 Sears house, The Westly, overlooking the Collegiate Peaks beyond the Arkansas River, replaced the original hewn buildings, which survive. Serving as the main ranch house ever since, the 1986 owners were the fourth family to live there, according to *Houses by Mail*. They reported that their home was solid.

site. The package was certainly ahead of its time in concept. Speed, ease, pre-cut lumber, specifications and instruction manuals—the ultimate how-to. Not surprisingly, the owners usually filled a hands-on role in construction.

Any Sears home could—and did—serve as a farmhouse. In the spring of 1914, the company announced the results of a farmhouse design competition. The story goes that Sears invited ì100 practical farmers' to work with a building committee in developing floor plans for 100 modern farmhouses. The marketing department had clearly targeted an opportunity to move the farmers out of their log and simple frame homes. First prize went to The Hillrose, a design that appeared in the catalogue until 1922. Ever open to new opportunities, the list of available designs expanded to barns, silos, hen houses, toolsheds, milk houses, corn cribs and hog houses.

"In 1917, after living in a two-room log cabin for 12 years, William and Mollie Lee, moved into their newly constructed Sears Modern Home No. 264P151, near Ray City, GA," the author states. The family described the house as large—with seven rooms, and 25 glass windows—and said they needed the room, because it grew to house seven children, various relatives and the schoolhouse teacher.

The counterparts in Canada were built by British Colonial Mills, Timber & Trading Company of Vancouver. Apparently, these models were easy enough to assemble that a relatively unskilled buyer could do the job.

The railroad transported the materials for the house to the nearest depot at Ray City, where-upon mule and wagon hauled it to the building

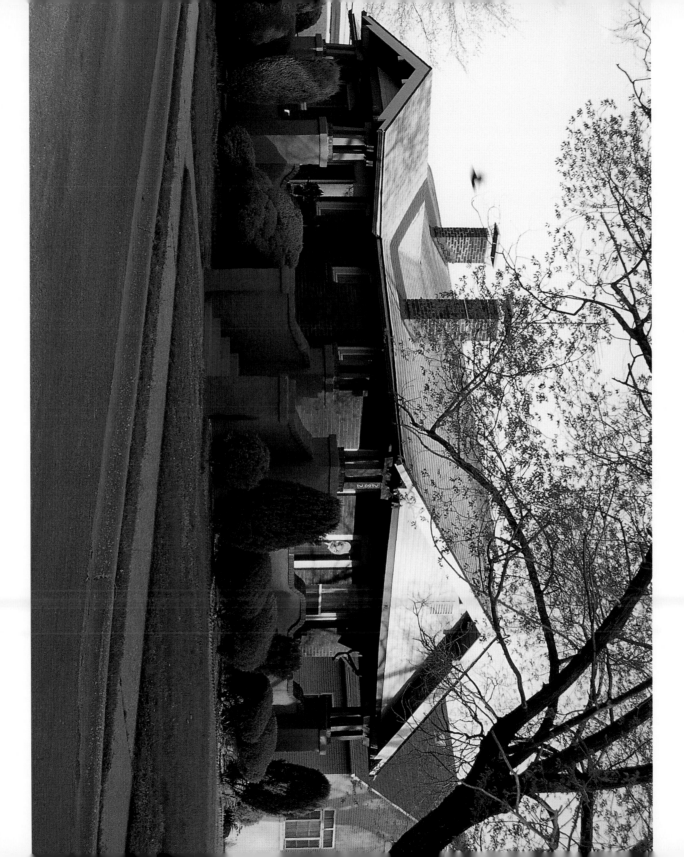

(Top) This is the Sears "Osborn model."
This house is also in Wood River, Illinois.

Some of the early houses can still be found
around Vancouver.

Although "prefab" subsequently earned a
less than stellar reputation, an entire new high
end industry has developed in the last decades
of the twentieth century around the concept of

"pre-built." Log houses are high on the list, as
are timber framed homes.

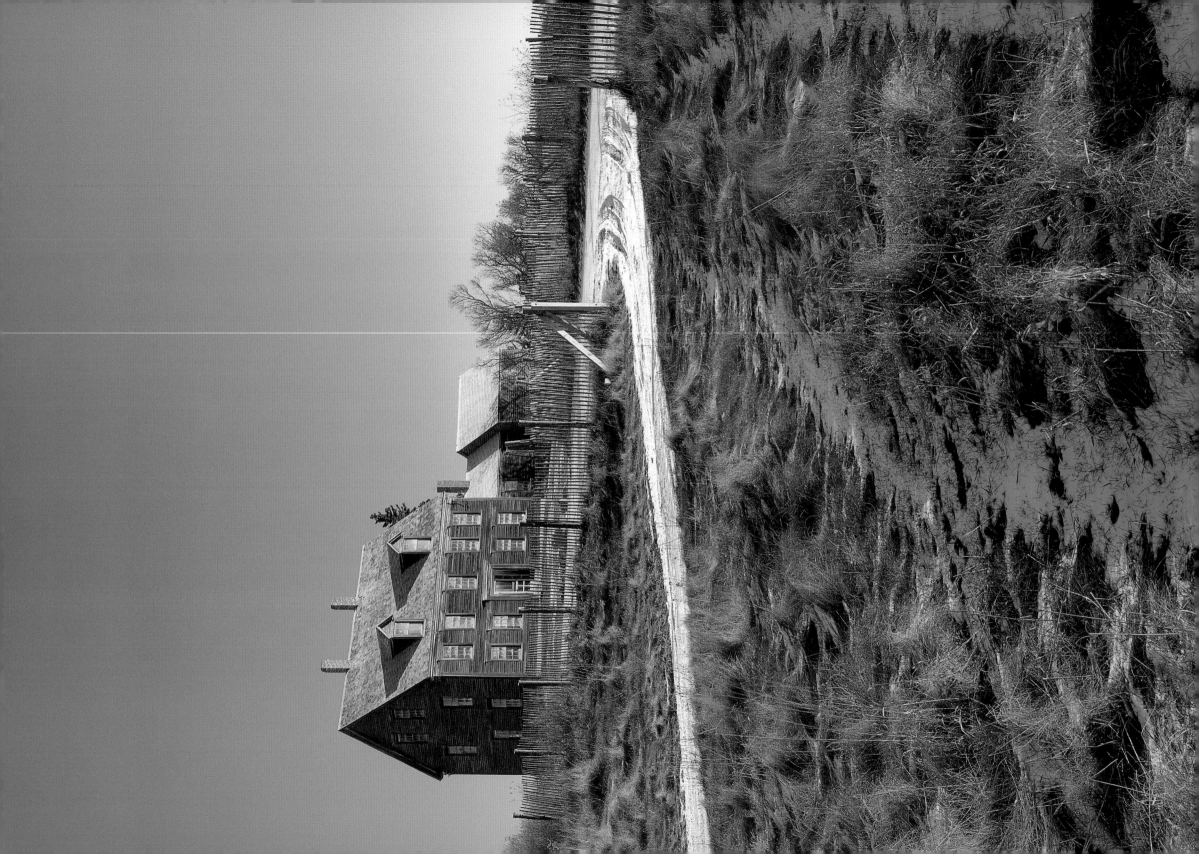

Whispers
from the Past

(Left) The Olson Farmhouse in Cushing, Maine, was made famous in Andrew Wyeth's painting, "Christina's World."

FROM THE EIGHTEENTH to twentieth centuries, the location of a farmhouse on a farm made finding one easy. By the dawn of the twenty-first century, farmhouse-finding became more difficult. A well-kept farmhouse may be surrounded by housing development—the house a last vestige of a former existence. Sadly, once solid farmhouses are among the deserted derelicts along highways and in commercial districts, crumbling as the farmers that produced them moved on to—literally—greener places. Two incompatible attitudes have evolved about old houses, especially farmhouses.

Because of the increasing value of the land around them, the choice is often between a commitment to loving restoration or "get it out of the way."

With simple lines that lend elegance, even the smallest ill-cared-for house exudes a sense of being worth saving. A "For Sale" sign on these homes doesn't seem to last long unless the community is so isolated that there is no economic base for support. Diligent searchers will find the treasures and those with the passion and patience required for restoration, adaptation and a new existence will win the prize.

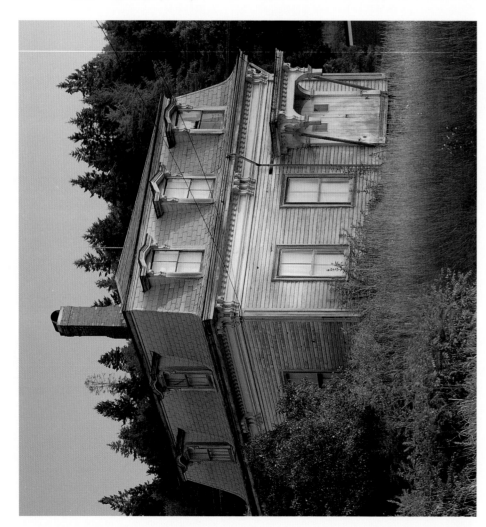

(Left) An abandoned Victorian home in East Machies, Maine.

(Overleaf) The photograph captures a Winterport, Maine house that had many additions. The house is no longer standing.

It's easy to get serious about farmhouse living if you are single, married without children (or with very young children) or at the edge of retirement. The complication for the periods in between revolves around education—good schools being the highest priority for most families. Country schools, like city and suburban schools, can be wonderful or awful.

For old farmhouses and land, look in the country. (Old farmhouses that fit more suburban needs require a tighter box in which to search.) Hunting down old country farmhouses isn't difficult. Old roads, especially those that the interstates pass by, are a good beginning. They har-

bor houses tucked away in inconvenient corners ignored by waves of development.

The perfect house doesn't exist. Each is the product of a family's needs at a certain time—spanning innumerable generations. Idiosyncrasies abound. The house described below was teetering at the brink of destruction when a man who couldn't bear to see it crumble rescued it. The current owner, an Englishwoman, administered the final loving touches to restore it and intends to spend the rest of her life enjoying its history.

Almost Gone. A sprawling growth of old privet hedge concealed a stone and stucco relic, a barn that struggled against gravity pulling it closer to the earth with every windstorm and heavy rain. A glimpse through the sagging double doors revealed broken plows, a rusting tractor, rakes, pitchforks and a two-seater

The perfect house doesn't exist.
Each is the product of a family's needs at a certain time—
spanning innumerable generations.

buggy. A weathered "For Sale" sign hung by one hinge on a tilting post by the driveway.

The farmhouse history is revealed in its structure. Deep windows, walls rounded at the sills and low-beamed ceilings stir thoughts of life in the eighteenth century. Time must have been kind for the first hundred years, until around the 1870s when a farmer with extra cash in his pocket decided to modernize. Gone were three blazing hearths, their openings bricked up to accommodate Franklin stove pipes. A built-in cupboard in the kitchen concealed a great walk-in fireplace, its height and angles accounting for strangely shaped shelves. A flat-roofed, two-story addition doubled the original size of the house—practical but not pretty.

Possibly forty years later, the slightly uneven, wide-planked pine floors were covered by machined boards, narrow and precise. A newfangled furnace in the cellar connected with a large grate in the center hall floor, belching erratic clouds of dust and quickly dispersed hot air. Along the way, electricity arrived—sort of. Loops of poorly concealed wires, scattered fuse boxes and an amazing variety of fixtures testify to gradual installation, room by room, year by year. The damp cellar is lined with sagging shelves holding hundreds of jars of canned vegetables and fruits. Overhead, solid beams have supported decades of tramping feet, and are capable of surviving many more lifetimes.

It's a relief to emerge into the sunlight, carrying the cheering thought that a new future may await this house now inhabited only by memories. Surely someone will come by to cut the brambles, throw the windows wide open and let sunshine and life reign again.

The stories of farmhouse inhabitants are as different as their personal backgrounds. Farming is not an easy life, but farmers seem to place high value on the psychic income gained from

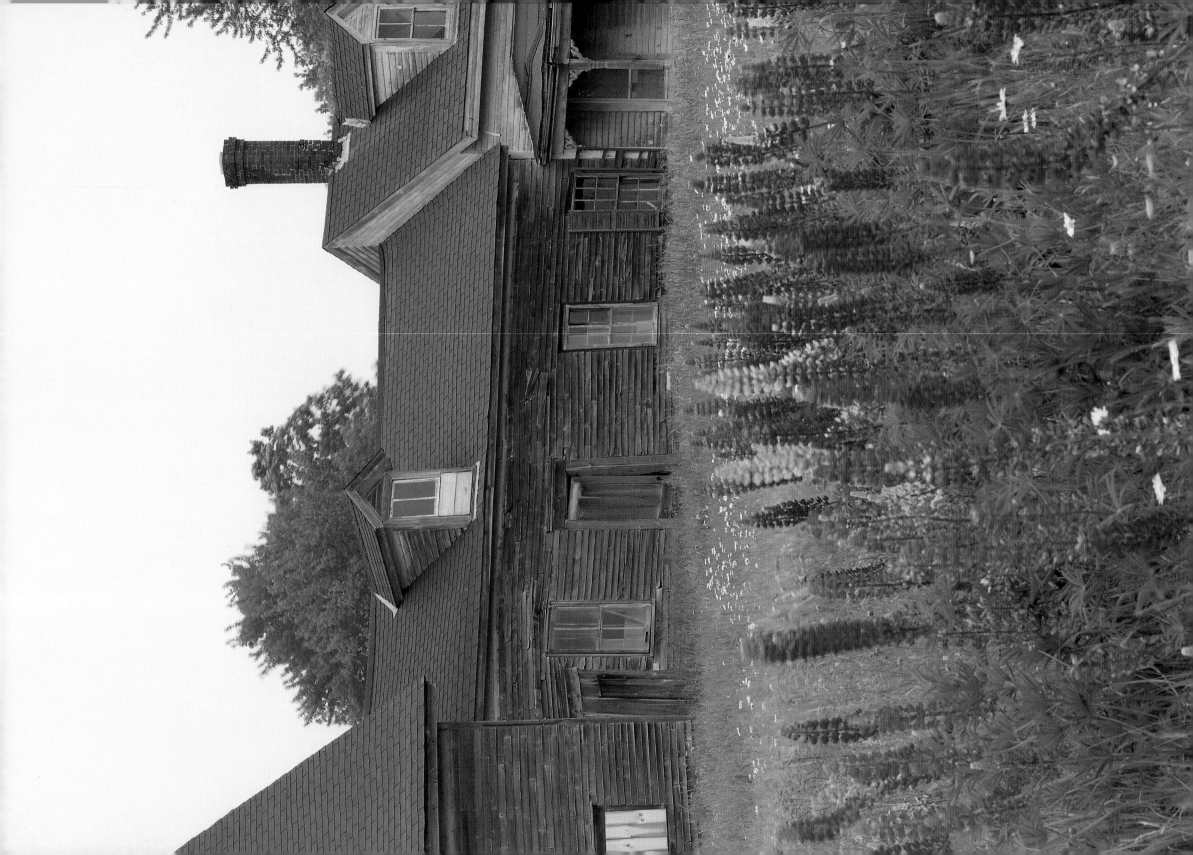

the connection with the soil, hard work and survival instincts. This ethic appeals even to those whose closest contact may be the garden shop in the supermarket. A short but true story reveals the struggle and, at the same time, the strength of that farm relationship—how deep the roots can grow.

I T WAS LUNCHTIME. The elderly farmer sat in his pickup truck reading the newspaper, a half-empty bag of potato chips and a cardboard milk carton beside him on the seat. I'd met him before and knew that the highest values in his life were the land and the animals. Never married, born here, living 80 years on the same farm, he was independent, although slovenly about house and self, yet worshipful of his cows and loyal to the few people that mattered.

I was nervous driving up the lane in my pickup truck, even though I wore jeans and an old parka. Working with a local land trust, I came to talk about helping him make sure his land was saved for farming. On a small knoll, a huge sycamore towered over the small white farmhouse—its simple, unshuttered lines accented by the bright sun and sparkling snow.

That day I held the halter of a cow he was doctoring for a cut. We talked about generations of the same family on the land. His wiry, gray hair stuck out under a battered John Deere cap. He wasn't interested in government money, didn't want anyone meddling in his business. He didn't object to my returning another time, liked to have visitors, but no, he didn't think it was time yet for him to plan about what came after.

A couple of months passed. I brought along a fresh-baked loaf of bread and stopped again. I found him in the barn, sniffling in distress, sitting next to the body of a young cow. "She was such a nice one, going to be a good breeder, too. Can't figure what happened, but she just came tearing into the barn, slipped and got stuck under the hayrack. So scared, she up and broke her neck." He sighed, climbed to his feet and said, "Called the knacker hours ago to haul her away, but no one's come yet."

We walked to the house. I hadn't been inside the house before, and once there, doubted I could do it again. We entered through a glassed-in porch, past two scruffy hounds sitting on an old couch. Scraps of the upholstery and

(Right) This abandoned farm, which must have been prosperous at one time, is from Maryland's Eastern shore.

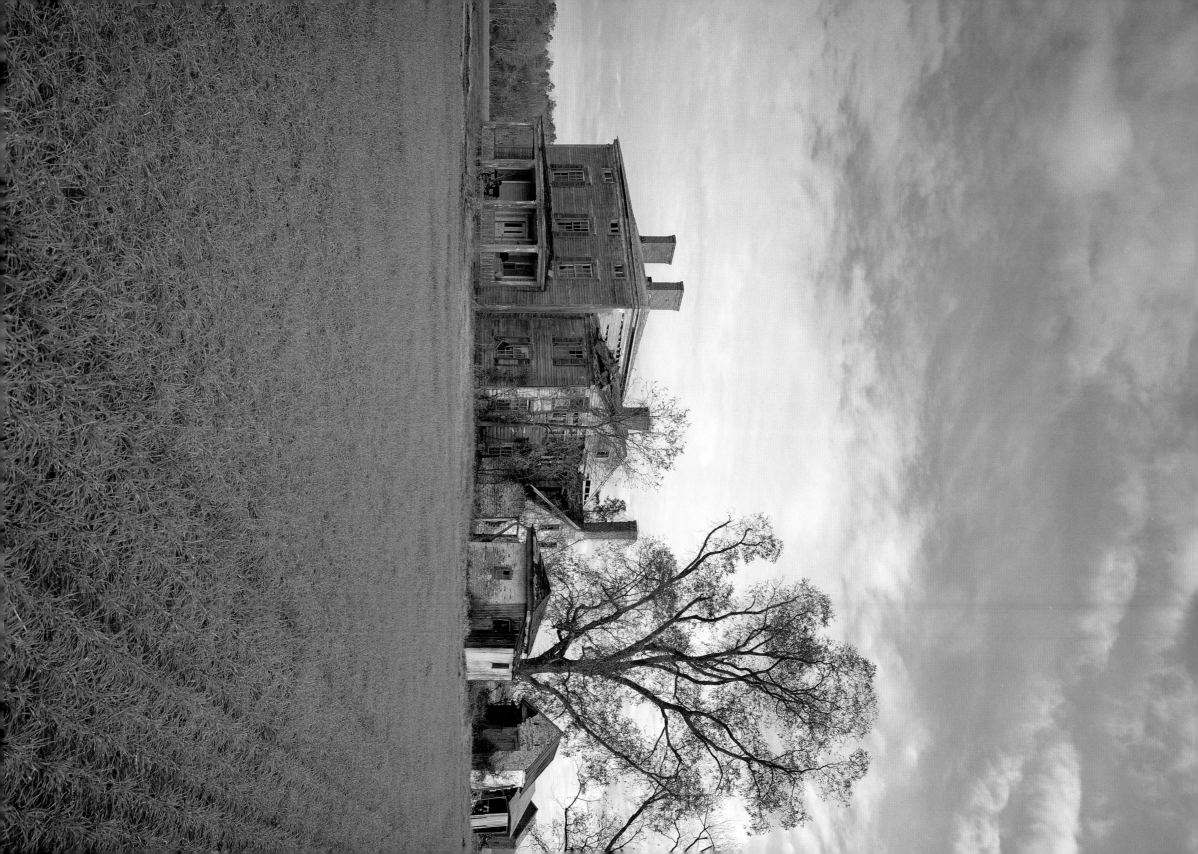

foam, along with tin cans, unwashed milk bottles and soggy old cartons created an obstacle course to the kitchen door.

The kitchen wasn't any better. Large black garage bags filled the corners, another claimed half the surface of an enameled metal table against the wall. A single straight chair and small corner of the table were reserved for eating. Pieces of moldy bread littered the surface. Mr. L. shoved trash off another chair and offered me a seat. Through the door to what was once the dining room and parlor beyond, I could see piles of newspapers, magazines and discarded old boots and shoes.

The house was cold. The barn was warmer. Running water there but not here. Mr. L. said he didn't spend much time in the house so there wasn't much use paying attention to it. He had a good lady friend once. She owned her own farm so they visited back and forth, and she cooked Sunday dinner. When she died, he was surprised to learn he was named her heir to the farm. He didn't know what to do with two farms, so he sold hers to a Mennonite neighbor with sons who wanted to farm, and held the mortgage so they could afford to buy it.

> Farming is not an easy life, but farmers seem to place high value on the psychic income gained from the connection with the soil and hard work.

We talked about his farm, what would happen after he was gone. He didn't know much about the law and what happened if you didn't have a will. There was a cousin that Mr. L didn't want anywhere near the farm. The idea made him mad. He said he'd think about a will.

As the seasons changed, I bumped into him occasionally at the feed store and always left a loaf of bread when I headed his way. One day, a notice appeared in the paper. Mr. L. had died after a short illness and a heart attack. I was worried that the farm would be sold for development, but the old man proved wise in the long run. He had finally written a will, bequeathing the farm to the Mennonite family and forgiving them the mortgage on the other

place. He must have decided that they were good people for the land, that they would feel the way he did about farming. He added a deed restriction. The property could never be subdivided. Crops, cattle and cows were just fine forever.

We think of housing developments today as gobbling up farmland, an activity that can be traced to the proliferation of automobiles and the construction of an ever-widening network of highways. Little could Gifford Pinchot have anticipated the long-term effect of his promise to

"get farmers out of the mud" by blacktopping single lane country roads when he ran for a second term as governor of Pennsylvania in 1931. Naturally he hoped to garner votes in return.

Remnants of those out-of-mud roads survive—reminders like a bump where a wooden bridge once spanned the railroad cut. During the years when the nation's economy was heavily tied to agriculture, farm votes were valuable and,

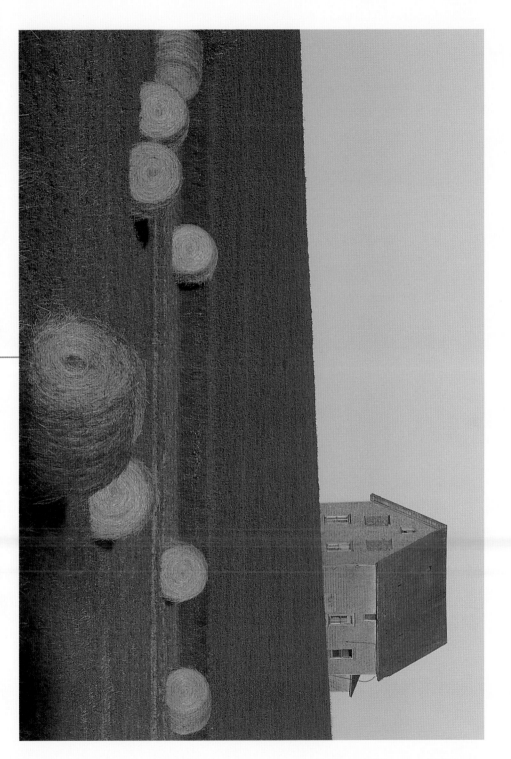

in each generation, farmers were influential in major elections—especially when getting out of the mud might make it easier to go vote.

Today, some of those same farmers might be happy to keep their mud—and hold the developers at bay.

The consumption of farmland for housing, however, was already evident in the nineteenth and early twentieth centuries. The difference was scale. As a family became more prosperous and dreamed of moving away from the town or city core, it built a house—and maybe another house nearby the next year. There was individuality to the houses that popped up one by one—even those that came out of the Sears catalog. The increase was orderly, far different from the modern development that sprouts anywhere from fifty to several hundred houses in a single year.

These latter may be houses on a farm, but in process the farm disappears. The farmhouse is often gone before the first new foundation is dug. As the country amenities and outbuildings disappear, an attractive sign announces that you have arrived at, say, Sunny Meadows Farms, a new community of "farm estates" beginning at $500,00. None of the complicated, turreted, six-

to-eight bedroom, three-car-garage homes, only slightly differentiated from one another, will resemble the farmhouse architecture it replaces—even though the original house's historic design integrity may well have been worth preserving as an artifact, as a signpost that other families lived in this space for generations.

There is the matter, too, of neighborliness. When transportation was slow and difficult, few people moved beyond the informal support system provided by neighbors. A large lot in the early twentieth century might have been a half-acre. Today there are hundreds of thousands of homes on one-, two-, even three- or four-acre lots, simply because the automobile makes it possible to live away from others. Computers, cell phones and the Internet further diminish the need for face-to-face interaction.

THE TRADE-OFF is the need to use a car to do the smallest errands, to take the children to activities, to schedule trips to the supermarkets and malls outside of commuter time because of horrendous traffic jams. These new settlers came looking for a way of life that they are unintentionally helping to erase.

(Left) Andrew Wyeth painted many interior scenes of the Olson Farmhouse in Cushing, Maine.

Even the residents who do opt for new over old—if they're willing to invest a little time and effort—can enjoy the history of the land upon which they now live. Just like the genealogy that many families find fascinating, one can trace the genealogy of the land, recreate a history of what happened in this place over generations.

Farmhouses remain the archeological treasures of a chapter in the history of the United States and the North American continent. In not much more than a hundred years, our society has moved from being almost heavily agriculturally based to the post-industrial era. In the process we are losing sight of the role the farmer played in settling the country. As farmers and their families give up tilling the soil—for reasons that range from natural disasters to economic hardship—the farmhouses they leave behind will either disappear or they can be saved. Unfortunately a great many will crumble. Those that survive represent the fabric of America with all the diversity that has made the country strong and resilient.

On the lighter side, restoring or living in a comfortable farmhouse can be a joy. There is also the joy of discovery that comes from roaming the back roads and speculating about the people who lived on the farms over the centuries. We think of their courage and the challenges they faced daily.

Certainly early farmers, who crafted their houses with primitive tools, had no luxuries and even few of the bare essentials. In the wide-open spaces of the Midwest, and especially through the plains and mountains of Montana and Wyoming, one can think of a lonesome prairie schooner or two venturing into the midst of the wilderness. When we come upon the disintegrating cabins and barns that were home to these pioneers and adventurers, we can wonder whether we would have the fortitude—or foolhardy spirit—to embark on such a mission.

We'll never really know whether we would have been successful pioneers and farmers, but we certainly can enjoy the appeal of their well-worn farmhouses—every style, from coast to coast. These houses offer welcome, warmth and a sense of all that came before. They each have a story to tell. They are well worth the search.

(**Right**) An example of a rural home in Deer Island, Maine.

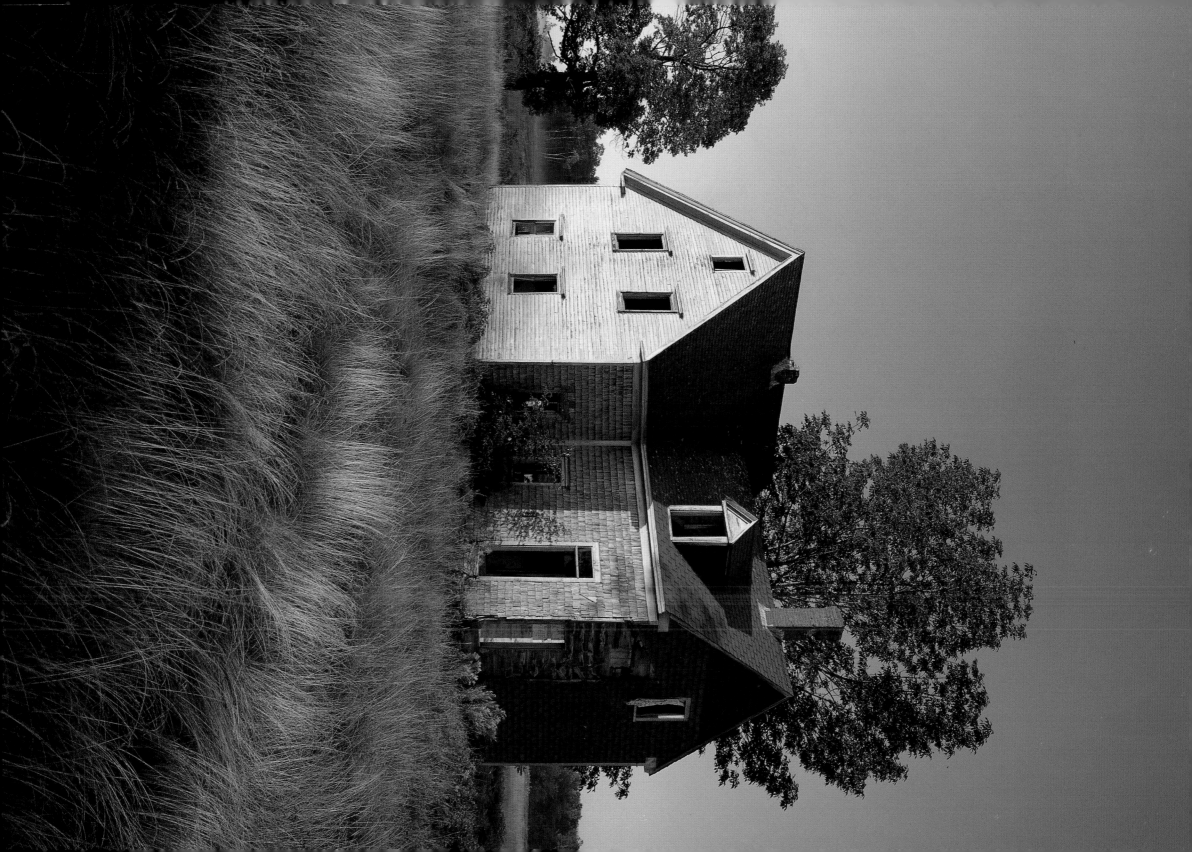

Photo Credits

©Tom Algire: pp. 12–13

©Barrett and MacKay Photography: pp. 10, 16, 42, 44, 45, 75

©Randl Bye: pp. 6, 8–9, 28, 29, 46–47, 50

©Richard Hamilton Smith Photography: p. 49

©John Day Mohr: pp. 14, 80

©Paul Rocheleau: back cover and pp. 15, 20, 24–25, 32, 33, 34, 38, 52, 53, 54, 57

©Rosemary Thornton: pp. 62, 65

©Brian Vanden Brink: front cover and pp. 4, 18–19, 22, 23, 26, 36, 40, 41, 56, 58–59, 61, 66, 68, 70–71, 73, 76–77, 79

©Brian Vanden Brink; Kris Horiuchi Landscape Architect: p. 7

©Brian Vanden Brink; Centerbrook Architects and Planners, p. 30.

Bibliography

CRUICKSHANK, TOM. *Old Ontario Houses: Traditions in Local Architecture.* Firefly Books, 2000.

FUTHEY, J. SMITH, AND GILBERT COPE. *History of Chester County Pennsylvania, with Biographical Sketches.* L.B. Lippincott & Co. 1881.

HISTORIC PRESERVATION TRUST OF LANCASTER COUNTY. *Lancaster County Architecture, 1700-1850.* Historic Preservation Trust of Lancaster County, 1992.

KAUFFMAN, HENRY J. *The American Farmhouse.* Hawthorn Books, 1975.

STEVENSON, KATHERINE COLE, AND H. WARD JANDL. *Houses by Mail: A Guide to Houses from Sears, Roebuck and Company.* National Trust for Historic Preservation, 1986

UPTON, DELL, AND JOHN MICHAEL VLACH, EDS. *Common Places: Readings in American Vernacular Architecture.* The University of Georgia Press, 1986.

WHITAKER, CRAIG. *Architecture and the American Dream.* Clarkson N. Potter, 1996.

WILLIAMS, HENRY LIONEL, AND OTTALIE K. WILLIAMS. *Old American Houses 1700-1850: How to Restore, Remodel and Reproduce Them.* Bonanza Books, 1967.

A Guide to Old American Houses: 1700-1900. A.S. Barnes and Company, 1962.

From the Web:

http://www1.umn.edu/urelate/kiosk/10.96text/peterson.html

Comments by Professor Fred Peterson, as summarized by Lynette Lamb.

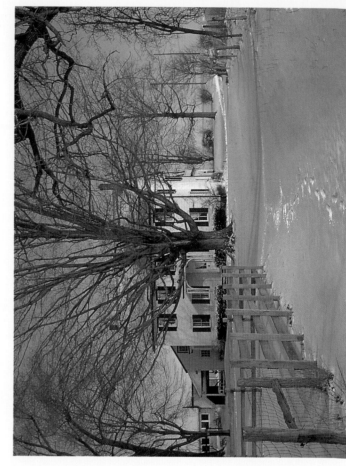

This green-shuttered farmhouse, built around 1837 with stone under the clapboard, is in Chatham, Pennsylvania.